LACQUERWARE MASTERPIECES FROM SOUTHEAST ASIA

The Collection of David Halperin

LACQUERWARE MASTERPIECES FROM SOUTHEAST ASIA

VITHI PHANICHPHANT AND
SYLVIA FRASER-LU,
WITH LINDA MCINTOSH

First published in Thailand in 2025 by
River Books Press Co., Ltd
396/1 Maharaj Road, Phraborommaharajawang
Bangkok 10200, Thailand
Tel: (66) 2 225-0139, 2 225-9574
Email: order@riverbooksbk.com
www.riverbooksbk.com
@riverbooks riverbooksbk Riverbooksbk

Copyright collective work © River Books, 2025
Copyright texts © Sylvia Fraser-Lu and Linda McIntosh, 2025
Copyright photographs © River Books, 2025
except where indicated otherwise.

All rights reserved. No part of this book may be reproduced or transmitted in any form or by any means, electrical or mechanical, including photocopying, recording or by any information storage or retrieval system without the written permission of the publisher.

Publisher: River Books Press Ltd., Bangkok, Thailand
EU Authorised Representative: Easy Access System Europe Oü,
16879218 - Mustamäe tee 50, 10621 Tallinn, Estonia,
gpsr.requests@easproject.com

Publisher: Narisa Chakrabongse
Production: Narisa Chakrabongse
Editor: Paul Bromberg
Design: Ruetairat Nanta
Photography: Pattana Decha (Bangkok) and Mark French (Hong Kong)

ISBN 978 616 451 079 1

Front cover: A group of six Southeast Asian lacquer wares

Back cover: (top) One of a pair of fans with a phoenix in the center, Burma, red lacquer decorated with colored glass (cat. no. 255), Burma; (bottom) a pair of mythical flying horses, Burma, molded decoration (cat. no. 315).

This and opposite page: Mythical flying horse, Burma, molded decoration, red lacquer on wood, early or mid-20th century, W 20.5 cm, L 65 cm, H 34 cm (one of pair, see cat. no. 315)

Printed and bound in Thailand by Sirivatana Interprint Public Co., Ltd

CONTENTS

INTRODUCTION by David Halperin	12
OVERVIEW OF LACQUERWARE TRADITIONS by Professor Vithi Phanichphant Translated by Narisa Chakrabongse	17
PRODUCTION, USAGE, FORMS, AND DESIGN MOTIFS OF SOUTHEAST ASIAN LACQUERWARE by Sylvia Fraser-Lu	25
BIBLIOGRAPHY	49
CATALOGUE	50
Baskets	52
Betel Boxes	66

Boxes	126
Mother-of-Pearl and Bone Inlay	160
Pedestal Stands	194
Plates, Trays, Bowls and Cups	206
Religious Items	234
Sculptures	270
Miscellaneous	290

Introduction

My interest in Southeast Asian lacquer developed soon after I arrived in Hong Kong in 1976 to take up a position with an international law firm. It was not my first visit to the Far East. Having attended college on a Navy scholarship, I spent my undergraduate summers on naval exercises, which included several trips to Hong Kong and Japan. I have an early memory of sailing into Hong Kong harbor one day in the summer of 1961 as the sun was rising, standing watch on the bridge of a destroyer. I remember looking up at the graceful, balustraded colonial houses dotting the hills of Hong Kong and wondering what it would be like to live in this magical city.

I graduated from college in 1965 and was commissioned as a Navy ensign in the summer of 1966. After two years aboard a troop transport ship traveling between San Diego and the coast of Vietnam, the Navy would soon give me an opportunity to return to Asia when I was assigned to Saigon (Ho Chi Minh City) in 1968 as an aide to the Deputy Commander of Naval Forces in Vietnam. On my short rest and recreation breaks in 1969 and 1970, I was able to return to Hong Kong, and enjoy my first visit to Bangkok, in what would become the first of many such visits.

After leaving the Navy and finishing law school in 1974, I had started work at a Wall Street law firm when I received a call offering me a job in Hong Kong. I quickly accepted, but only after settling into Hong Kong as a young lawyer in 1976 did I take an interest in the art, antiques and craft traditions of Southeast Asia.

My first trip to Burma (Myanmar) was in 1977 when I was representing a consortium of European banks arranging a syndicated loan to the People's Pearl and Fisheries Corporation, one of the first foreign currency loans to a Burmese government organization. The loan was ostensibly to finance the purchase of a fleet of fishing boats. To advise on the legal aspects of the loan, I had to find lawyers in Rangoon (Yangon) able to advise on the government approvals needed, and to meet the many government officials who had to approve the loan. But in my free time I began exploring the markets, and in the lanes and alleys of what was then called Scott's Market (now Bogyoke Market), I first noticed the lacquer crafts in the many shops selling both new lacquer and older pieces. This is where my interest in collecting lacquer first developed, and some of the early pieces in my collection were bought during those early visits.

Travel to Burma was restricted during much of the 1980s and 1990s, with visitors limited to the number of days they could spend in the country and the amount of foreign currency that could be imported. However the border between Burma and Thailand was porous, with many works of art and antiques arriving in antique shops dotted throughout Bangkok, many located in Chatuchak, the weekend market where products of every description could be found. Bangkok was a popular weekend destination from Hong Kong, and I made regular trips there throughout the 1980s and 1990s, always finding time to visit the weekend market and other antique dealers, while developing relationships with some of the dealers who specialized

INTRODUCTION

in lacquerwork. Some, I noticed, had special connections in Cambodia, others specialized in Thai lacquer, including from the Chiang Mai area, and others focused more on lacquer and other works of art from Burma.

In 1993 I persuaded my law firm to establish an office in Bangkok which provided more opportunities to spend time there. I began to expand my collection, acquiring one or two pieces on every trip. Eventually I bought an apartment in Bangkok which provided ample storage and display space for my expanding collection.

More craft than fine art, the appeal of lacquer to me has always been the creativity of the unknown craftsmen who introduced into their work distinctive designs, shapes, and patterns, often slight variations of more common themes. Many of the objects in the collection are of the ubiquitous betel box and other ordinary objects for secular use, but also included are lacquer wares for religious and ceremonial use, including statuary, stands, fans and manuscript boxes. Coming across pieces with slightly unusual features, designs or shapes, even if only slightly different from more common designs, is gratifying to any collector, and it is that excitement of discovering something distinctive or unique that has given me such pleasure and satisfaction as I slowly added pieces to the collection. I have spent many happy hours over the years roaming the alleyways of Bangkok's weekend market, Phnom Penh's Russian market, and Scott's Market in Rangoon, spending time with dealers and learning from each of them.

Although the lacquer traditions of each of the Southeast Asian countries are in many ways similar, there are some distinctive differences which have not been well documented, though several important books on Burmese lacquer have been published in recent years. Most of the pieces I have collected have come from Burma, which has the richest (and best documented) lacquer tradition, but Cambodian lacquer can also be very refined and distinctive, while Thai lacquer has its own distinctive color palate and designs. Both Thailand and Cambodia have a well-developed tradition of lacquer pieces embedded with intricate mother-of-pearl decoration; the beautifully illustrated book *Thai Mother-of-Pearl Inlay* (2001) by Julathusana Byachrananda includes some of the best Thai examples in private and museum collections. However Cambodian mother-of-pearl lacquer objects are comparable in quality, but not as often seen or illustrated.

In my collecting adventures, I have tried to acquire both very good examples of relatively common forms and designs from each country, but also – and this provides the most excitement – focusing on lacquer objects of unusual forms or design that have not been well illustrated in the literature. This book is not a work of scholarship – much important work in this area has already been undertaken. Sylvia Fraser-Lu, who has kindly contributed an essay for this volume, wrote one of the first books on Burmese lacquer, *Burmese Lacquerware* (published in 1985 and later expanded and revised in 1990). The seminal work of Ralph Isaacs and Richard Blurton in their book *Visions from the Golden Land* (2000) provides an excellent introduction to the history of Burmese lacquerware, as well as the techniques of production; they also translated the inscriptions and provided detailed information about the 269 pieces of Burmese lacquerware given to the British Museum by Ralph and Ruth Isaacs in 1998. More recently, the late Than Htun, whose shops I often visited in Rangoon,

published the very important book *Lacquerware Journeys* (2013) which provided detailed descriptions of the distinctive regional differences in Burmese lacquerware from all the major production centers of the country, also commenting to a lesser extent on Thai lacquerware. One of the few books dealing with the lacquerware of all of the Southeast Asian countries, *Lacquerware in Southeast Asia* (2015) was written in Thai by Professor Vithi Phanichphant who lectured on this subject for many years at Chiang Mai University. Professor Vithi kindly gave permission for his book to be translated, and Narisa Chakrabongse undertook to provide an English translation, key parts of which have now been incorporated into one of the essays in this volume. Professor Vithi's important book has allowed me to confirm with some confidence the origins of some of the pieces in my collection. His chapters on Khmer, Lao, Thai and Shan lacquerware were particularly helpful.

It is generally difficult to date lacquerware. Most of the objects I have collected date to the 20th century, a few are 19th century (or possibly earlier), while I also wanted some examples produced more recently (within the last twenty years). These more recent pieces provide encouragement that the art of fine lacquerwork continues to thrive. I have in the catalogue provided my own very broad indications of the age of each piece, but with unsigned and undated lacquerware, dating remains an imprecise art. Where pieces in the collection are similar to pieces which have been included in the major books on the subject, I have provided a cross reference without attempting to summarize the additional information provided for the referenced objects.

I owe a huge debt of gratitude to Amanda Clark, my business partner in Altfield Gallery which we started together more than 40 years ago in Hong Kong. She encouraged me over the years to work on a book focusing on my lacquerware collection, as did Regina Krahl many years ago. The book would not have come into being without the assistance of Paul Bromberg who helped to manage the project from inception to conclusion, while also kindly editing the text. He reached out to Sylvia Fraser-Lu to request that she provide the main essay for the book, and also to Linda MacIntosh in Luang Prabang who kindly provided input with an essay on Lao lacquerware and introductions to a Lao collector. Narisa Chakrabongse kindly agreed for River Books to publish the book after seeing only a very brief summary of what was intended.

As with any collector, I have learned and been educated by the many dealers from whom I have acquired objects for my collection. The late Surapol Leeruangsri of August 11 in Bangkok was an expert in Cambodian lacquerware, and I have acquired many pieces from his shop in River City over the years. Chanvit Guongariyanon of Nai Huad Antiques in Chatachuk market also regularly reserved unusual lacquer pieces for me, also mostly from Cambodia, and the late Mrs. Young of Young's Antiques always had some interesting Thai pieces to show me, as did her daughter who has carried on the business. Both Cathy Vandewalle and her colleague Yee Yee at Verandah Gallery in River City have been a great resource, and were always helpful. Ms. Punvasa Kunlabutr of Lampion Gallery is extremely knowledgeable and has patiently provided an informed view on dating and regional provenance of various pieces in my collection. Mr. Surat Saelao, a dealer in Lao

silver and crafts, has also been helpful in confirming the Lao origin of some pieces in the collection, and Chuchart Naksith has been both a friend and an advisor as I pursued my collecting interests. There have been many dealers in Rangoon and Phnom Penh who would always have pieces to show me; sitting with them and discussing the new items in their possession was a source of endless enjoyment.

My able assistant Karina Chau spent countless hours helping me prepare, edit and correlate the descriptions of each of the pieces in the collection – not a simple task – and I am also appreciative of the hard work of measuring each of the pieces undertaken by Romeo Arlalejo and John Galedo who faced logistical challenges as the collection has been stored in multiple locations. I am very grateful for all their help in bringing this project to fruition.

Assembling this collection over more than forty years has given me immense joy and satisfaction, and I hope this book will provide encouragement to other collectors with an interest in the lacquer and other craft traditions of Southeast Asia.

David Halperin
Hong Kong, August 2024

Overview of Lacquerware Traditions

by Professor Vithi Phanichphant

Translated by Narisa Chakrabongse

Burma (Myanmar)

Society in Burma is composed of various ethnic groups who have over a long period been producing and continue to produce lacquerware, known as *thit sa*, in great quantities. Burma shows a development in lacquerware production greater than any other Southeast Asian country, and the lacquerware has a clear identity in its diverse forms and designs. Furthermore, lacquerware continues to be widely used by local people whether in the temple, at the market, or at home, unlike elsewhere where lacquerware is now used only sparingly in the home as it is regarded as a precious item for religious ceremonies or simply as a souvenir.

Lacquerware items are manufactured via small-scale businesses for everyday use and for sale in the local market and abroad. In the past, the different regions of Burma would have their own identity and clearly defined tastes based on shapes that were appropriate for their purpose (**1**). Those using lacquerware in Burma can be divided into two main groups: the Tai Yai from Shan State and the Burmans in the lowlands in the middle of the country. Lacquerware is now also a popular tourist product, which has led to new forms or to the copying of old forms from different areas, making it difficult to identify the origin of particular pieces.

1 Three Burmese cylindrical betel boxes

LACQUERWARE MASTERPIECES FROM SOUTHEAST ASIA

2 A group of four Shan betel boxes

Although it is often said that Thais learned lacquerware techniques from Burma, some Burmese academics and craftspeople contend that the Burmese actually borrowed influences from the Thais. Whatever the truth of the matter, there has been lacquerware production in Burma for a long time and there is a great deal of evidence attesting to this. Moreover, it can be seen that the interchange of cultures, both as neighbors and as a result of seizing craftspeople as one of the spoils of war, may have led to new techniques and innovations.

Lacquerware from Shan State

Shan State in the north of the country is home to many Tai people (Tai Yai). The lacquerware they produce is not very different from that made by the Tai in other regions. However as the area is abundant in the raw materials needed to create lacquer objects, a greater and more diverse product range is found here than in other areas of the country and Shan products have some unique characteristics in terms of forms and design motifs not found anywhere else (**2**).

Cambodia

Cambodian or Khmer lacquerware called *khmuk mreak khmer* is very similar to lacquerware found in the Isaan region of Thailand, although the quality and skill of Khmer craftsmen seems of a higher level. In the past, Khmer lacquerware was found in every household. One of the characteristics of Khmer lacquerware is keeping a rough surface and revealing the woven framework as part of the decorative schema in contrast with the smoother regions. Another important feature is the edging of receptacles with split bamboo in beautiful patterns, which are embedded firmly into the lacquer. Motifs used include those derived from nature or geometric designs similar to *mudmee* textiles or carved wood (**3**).

Lacquerware production centered on areas where the requisite materials were readily available, notably in the central Kompong Thom province. Common Khmer lacquer wares include:

3 A Cambodian circular lidded offering vessel

1) Betel trays made using a framework of either woven split bamboo or wood and made into a round receptacle. It is decorated with flowers by applying drips of lacquer and then gold leaf to create a raised design. Khmer betel trays are placed on another tray, which is generally real wood and either square or hexagonal. Sometimes the lacquer is molded and affixed before being finished with gold leaf.

2) A covered vessel called *toh baad nam mon* with a tiered lid often topped with a lotus bud which is mainly used in religious ceremonies. It is often decorated with spots of lacquer and gold leaf, and sometimes inlaid with mother-of-pearl or glass mosaic. Large examples are used to serve food for nobles or monks.

3) Candle boxes made from split bamboo which is very skillfully woven and then coated with a layer of lacquer.

In addition Khmer craftspeople like to decorate various everyday objects with lacquer such as spindles and other weaving equipment, baskets, threshing baskets, boxes, food receptacles, alms bowls, and items of furniture and musical instruments used in religious ceremonies (**4**).

Unfortunately, the art of traditional lacquer production has almost died out in Cambodia as historical and technical knowledge and expertise disappeared along with the many lacquer practitioners who died under the genocidal Khmer Rouge regime (1975-1979). Moreover there is also now a general lack of the raw materials required as a result of deforestation.[1]

Laos

(With additional input from Linda McIntosh)

Lacquerware is as widely used in Laos as in Thailand and Burma though the forms of Lao lacquerware differ according to the particular region and ethnic group. In addition to being a primary material used to produce storage containers and utilitarian items, it is in Laos also a key form of waterproofing to protect wood, bamboo, rattan, and other materials such as pottery and leather from rain and humidity, insects, and mold. It was applied to both utilitarian and religious or ceremonial items. Buddhist monks historically have used alms bowls woven of

4 A group of six Cambodian rectangular boxes

1 An Sitha, "Cambodian lacquer art and Khmer lacquerware" in *Lacquerware in Asia, today and yesterday*. UNESCO Publishing, 2002, p. 169-170.

LACQUERWARE MASTERPIECES FROM SOUTHEAST ASIA

5 A Lao open basket with shoulder strap

split bamboo and covered with plain black lacquer that were very light and easier to clean than those made of metal or earthenware. It was also used in creating religious artwork, often covering wooden elements of Buddhist temple buildings and creating stucco-like decorations adorning pillars, window and doorframes, and other elements. Metal was also covered with lacquer to prevent the formation of rust.

A hierarchy of materials consisting of four categories evolved for storage containers or baskets, and lacquerware was ranked third. Gold and silver occupied the highest two levels while wood, bamboo, and rattan were the lowest-ranking materials. Incised or multicolored decoration on Lao lacquerware regardless of origin is rare, and the inlay of glass and adornment with gold leaf, including three-dimensional elements composed of putty and covered with gold leaf or a similar-looking material, defines the lacquerware style of northern Laos or Luang Prabang. Artisans used putty, or *kha mouk*, composed of lacquer with various ingredients such as dried cow dung, sand, and ash, creating thin threads that they placed strategically on a lacquered surface to compose delicate, organic patterns. Molds allowed for the creation of three-dimensional elements.

Northern Laos

The Luang Prabang style is reminiscent of Keng Tung (in Shan State) lacquerware, and a particularly distinctive lacquerware item associated with Luang Prabang is the *sa nam kieng* or an open basket with a shoulder strap that elite Lao women used for almsgiving. A *sa nam kieng* formerly owned by Tiao Sangiemkham from the viceroy or *vang naa* lineage of Luang Prabang, presently in the collection of her grandson Tiao David Somsanith, is an archetypal example (**5**). Gold butterflies adorn the basket's legs, and its feet are also gilded. A band of gold leaf decorations composed of flowers and downward-facing flames encircles the top edge below the basket's mouth or top rim, and round pieces of glass fill the centers of the flowers and flames. A section of open latticework occurs at the basket's "waist" or just above the legs. A pair of metal handles was affixed to the basket's rim while it was being coated with lacquer to allow for the use of a shoulder strap.

The framework of Lao lacquerware, whether of wood or woven split bamboo, is generally coated entirely with black lacquer (**6**). In the north, baskets known as *kat*, woven from split bamboo or rattan, are commonly used in daily life – whether going to market, to the rice fields, or to the temple – filled with merit-making items, food or betel-chewing paraphernalia.

Kata nam kiang are woven baskets coated with black lacquer on the outside and painted red inside. The sides slope in from a wide mouth to a narrow base, there are two carrying loops for a rope or cloth strap. The top edge of *kata* from Luang Prabang are usually painted with gold designs or covered with bands of gold leaf for special occasions and transporting items to the temple.

Tiao David Somsanith also possesses another family heirloom, an unusually

large round container, reminiscent of a betel quid ingredient box that also emulates Kengtung style in its decoration. However, due to its size and the amount of gold leaf adornment, it likely held a ceremonial function in the palace (**7, 7a**). On the exterior of this golden box, the red cinnabar background is visible in the middle where high-relief gold putty decorations of mythical animals prance amongst a flowering vine. The interior is red, and an unique element is a three-dimensional figure of a mythical animal on the bottom. The woven inner tray is also red with gold leaf around its lip.

Southern Laos

Extant lacquer wares originating from Champasak and neighboring areas of southern Laos are rare and resemble Khmer examples of this craft with a natural black or red cinnabar background. Decoration includes wood inlay and delicately drawn gold designs resembling textile patterns. Southern Lao lacquerware consists of wooden betel boxes whose shapes range from round to square and octagonal, as well as everyday tools and objects such as boxes, offering vessels, arrow sleeves, shields, sword scabbards, and weaving equipment.

Thailand

Thailand has a rich and diverse culture, borrowing from neighboring countries and influencing them in return. Lacquerware is no exception, resulting in Thailand having a diverse range of lacquerware items, evolving over time as a result of economic circumstances, a developing society, and war. This mix of historical influences, coupled with differing tastes has created lacquerware forms and styles that are quite unique and recognizable as embodying local tastes and requirements.

The Central Region

Lacquerware, called *krueng rak* or *krueng long rak*, was mainly produced in the service of certain sectors of society such as Buddhist monks, the nobility and wealthy elites. Lacquerware in this region may be compared to that produced in Vietnam and Cambodia, possibly a result of trading exchanges and political links. Nevertheless Thai people knew how to make lacquerware before the country even became a kingdom. During the Sukhothai period there is considerable evidence for the use of lacquer and cinnabar, such as traces of lacquer found on Buddha images.

In the Ayutthaya period there were significant developments

6 A Lao circular gilded container, the exterior decorated with a floral pattern on a black ground

7 A Lao circular gilded container, the exterior decorated with mythical animals dancing amidst flowering vines

7a Detail of the interior in red depicting a mythical beast in the center

in the art of lacquerware which are believed to be a result of interaction with China. Apart from on Buddha images, lacquer was also used for everyday items. In this period craftsmen seem to have been more skilled in the art of lacquerware. Knowledge managed to be passed down from the Ayutthaya period to that of the Rattanakosin era via those craftsmen who remained from the royal court. Lacquerware production was encouraged by the elite and it became more widely popular among both the nobility and wealthy commoners. The lacquerware was very refined with craftsmen being able to exhibit their skill and imagination. Most of the examples of lacquerware that remain from the Ayutthaya period and into the Rattanakosin period are pieces created for temples. Examples include doors for the *ubosot* or *vihara*, Buddha images and ritual objects, furniture, scripture cabinets, etc.

Most of the lacquerware produced in the central region was *lai rod nam*, gold appliqué on black lacquer involving complex techniques and great skill. The addition of mirror mosaic using tiny pieces of glass was also popular. Sometimes mother-of-pearl was also introduced with the pieces being intricately carved (**8**).

To make receptacles using gold and black lacquer, the framework was generally created from coils of split bamboo to make *talum* (pedestal trays), bowls, or stem trays. Turned wood is also found with the surface smoothed down before applying multiple layers of lacquer.

Gold on black lacquer was extremely popular among royalty and elite society as a sign of wealth and status and there were prohibitions on ordinary people possessing such ware. Monks were exempted from this law and accordingly a great many items of gold lacquer appliqué may be found in monasteries in the central region.

Isaan

Overall the culture of Isaan may be compared to that of Laos, Cambodia and even those of some indigenous groups. Accordingly the shape of lacquer objects and their usage is very similar, as well as the construction process. Isaan people like to use lacquer sap from the *Rhus succedanea* tree which does not give a deep black lacquer but is clearer and shinier. At the same time it gives a surface rather smooth

8 A group of four mother-of-pearl pedestal trays

OVERVIEW OF LACQUERWARE TRADITIONS

to the touch. The beauty of Isaan lacquerware comes from its simplicity of shape and design compared with the central region and the north. In addition it seems that the use of lacquerware in Isaan was more widespread among ordinary people when compared with the central region where its use was confined to the elites and wealthy people.

The North (Lanna)

Lacquerware has always been very popular in Lanna and remains so to this day. Although its role in everyday life has now been replaced in many cases by modern alternatives, lacquer goods are still produced in greater quantities than elsewhere in Thailand (**9**). Every household would previously have had lacquerware items. In many cases, the form and decoration of the lacquerware would signify to which social or ethnic group the owner belonged. The constant migration of the Tai Lao groups led to the exchange of both forms and designs from one place to another.

After the revival of Chiang Mai in the early 19th century, the areas around Wua Lai Road, Wat Nantaram, Ban Chang Lor became communities of Tai Koen and Tai Yai people who were skilled in many types of handicrafts, including making lacquer utensils. Lacquer production was not traditionally confined to Chiang Mai but was found in many other areas of the north. Overall lacquerware produced in different northern centers shared many commonalities in form, the substrates and decoration, varying only in minor details.

Current status

The popularity of gold on black lacquerware as seen in the central region has been an important driver of change to Chiang Mai lacquer work. The increased demand transformed production from being a handicraft made in the home to a small industry. The expansion of mass tourism has led to increased production of lacquerware souvenirs. Increased competition has also led to an emphasis on quantity over quality so that there has been a decline in quality, as well as very cheap fake lacquerware entering the market.

9 A group of five Lanna betel paraphernalia and other objects

Production, Usage, Forms, and Design Motifs of Southeast Asian Lacquerware

by Sylvia Fraser-Lu

Background

The topography and climate of mainland Southeast Asia, situated between the Indian subcontinent and China, have resulted in a biodiverse environment supplying many of the essential materials for lacquerware – bamboo, rattan, hard and soft woods for the manufacture of substrates, as well as lacquer resin, along with various oils, adhesives, and other additives required for surface creation and decoration. Moreover, the seas that surround the shores of mainland Southeast Asia furnish the nacreous mollusk shell used in Thai and Cambodian lacquerware.

Buddhism and Animism

Early architectural and statuary remains uncovered throughout Southeast Asia strongly suggest that Mahayana, Tantric, and Theravada Buddhist beliefs came to the region during the 1st to 3rd centuries via trade relations with India, Sri Lanka, and China. In the early kingdoms of Southeast Asia, it would appear that Hindu and Mahayana Buddhist practices initially held sway, before being largely supplanted by Theravada beliefs emanating from Sri Lanka. Contact with neighboring polities, both friendly and hostile, resulted in the spread of the Theravada faith throughout mainland Southeast Asia

Historically Buddhism has been officially sponsored by rulers of individual states throughout mainland Southeast Asia. As "defenders of the faith", the rulers served as the secular arm of Buddhism, charged with creating conditions under which the religion could flourish by keeping the doctrine pure, resolving disputes and schisms, and enforcing monastic discipline. In return the ecclesiastical authorities generally supported royal prerogatives and encouraged the population to obey the central authority. Adherents of Buddhism number over ninety percent of the populations of Cambodia, Thailand, Burma (Myanmar), and lowland Laos. Theravada Buddhism has primarily provided a similar worldview and a social cohesion that has enabled the inhabitants within each nation to participate in a common culture. Paralleling a devotion to Buddhism are various shared animistic beliefs that center on the propitiation of a host of spirits protecting the household and honoring the ancestors.

European influences

Early Portuguese, Spanish, Dutch, and later English, and French contacts with Southeast Asia in the 16th/17th century were largely commercial, highly

competitive, and monopolistic. The 19th century industrial revolution in Europe created an insatiable demand for reliable sources of raw materials and the need for new markets to sell surplus manufactured goods, leading European states to assert territorial and political control over much of resource-rich Southeast Asia. Burma was conquered in three stages and added to British India, while Vietnam, Cambodia, and Laos came under French control. As a buffer zone between the two powers, Thailand suffered the loss of some territory, but managed to maintain its independence.

Colonial policies were not generally nurturing of native crafts which were considered largely superfluous to plans for economic advancement. Both the French and English however did establish art schools to teach the rudiments of Western art. The French set up the *École des Beaux Arts de l'Indochine* in Hanoi in 1925 with a curriculum that aimed to combine Western and Eastern art traditions. Students were mostly Vietnamese but a few were from Laos and Cambodia. Courses in drawing, linear perspective, chiaroscuro, sfumato, watercolor and oil painting were taught and pupils were encouraged to apply what they had learned to the traditional arts such as painting on silk and lacquer with a view to developing an indigenous style. Students experimented with mixing lacquer with pine resin for a greater sheen and the layering of various materials such as inorganic pigments, eggshell, metal foil, and gold dust to develop a distinctive picture-making technique unique to Vietnam. A similar school, Royal University of Fine Arts, was established even earlier in 1917 in Phnom Penh in the Protectorate of Cambodia, specializing in architecture and the fine arts.

The British in Burma also established art schools that offered instruction in watercolor and oil painting techniques. Burmese crafts, including lacquer, were sometimes criticized by colonial administrators for being "barbaric" in form and "finicky in design". In their desire to "improve" native handicrafts regular exhibitions and competitions sponsored by the government were held. Winners were selected to exhibit and compete for prizes at Empire exhibitions. Craftsmen were prevailed upon to open shops with ready-made goods for sale. In a break from tradition, workshops and artisans were encouraged to inscribe their wares with names, dates, and places of manufacture in Burmese. Previously if there was an inscription it would usually only be the name of the owner or the donor of an object. Lacquerware artists also began adding captions in Burmese to identify the narratives depicted on their work. During the colonial period lacquerware production was in serious decline due to the increasing widespread use of cheap mass-produced glassware, ceramics, and later plastics. The lacquerware industry in Pagan (Bagan) was kept alive in part by the founding of a Government Lacquer School in 1924, set up at the urging of local Burmese officials.

The Lacquer Process
The Lacquer Tree

The lacquer tree *Gluta usitata* is native to Assam, Burma, Thailand, Laos, and Vietnam. In Burma the lacquer tree grows in Shan, Karen, and Rakhine states and in northern Thailand in the Chiang Dao and Fang districts of Chiang Mai as well

as the Khun Yuam and Pai districts of Mae Hong Son. The wood, commercially known as Borneo rosewood, is used for furniture and inlay work. A similar species known as *Gluta laccifera* native to Vietnam, Laos and Cambodia is a major source of lacquer in Cambodia. The species thrives in the central provinces of Kampong Thom and Kratie, and in upland areas of Laos. As members of the *Anacardiaceae* (sumac) family, lacquer-yielding trees are characterized by the presence of resin ducts that yield thitsiol (laccol).

Lacquer resin is obtained by making a pair of V-shaped incisions into which a shunt is inserted at the base of the tree, allowing the viscous sap to trickle into an attached cup. Up to four or five incisions may be made on a mature tree, which is then left to heal for a few years before being tapped again. Controlled tapping does not seem to have an adverse effect on the life of a tree.

On collection, the whitish raw lacquer thickens and turns a glossy black on contact with the air. It is strained to filter out impurities before being stored for future use in airtight containers to prevent coagulation. It is generally graded in quality according to water content: higher water content results in a less desirable more opaque appearance. Heating the lacquer prior to use is necessary to evaporate the excess moisture and to promote the polymerization of the thitsiol or laccol molecules to ensure a durable hard lustrous lacquer coating. Dependent on water and oxygen in the air, lacquer dries best at warm moist temperatures between 16-30 degrees Celsius and at 70-80 percent humidity. Drying cupboards offering a humid dust-free atmosphere are used to promote the hardening of the lacquer.

Substrates

Lacquer is a coating material which requires a core or substrate on which to create a lacquer body or form. An excellent adhesive, it can be applied to many surfaces, such as wood, bamboo, cane, palm-leaf, paper, fabric, leather, metal, stone, and cement. Heat, water, insect, and mildew resistant, lacquer resin stiffens, strengthens, and preserves the surface to which it is applied. It can be colored, molded, and sculpted with the addition of powdered additives. Although not the most durable, bamboo and wood being the most readily available and versatile to work with, are by far the most popular substrates for Southeast Asian lacquer.

Bamboo

A fast-growing hollow perennial grass that abounds in Southeast Asia, bamboo is integral to rural existence. A majority of lacquered objects in Southeast Asia are receptacles fashioned from split bamboo. Virtually every activity in rural Southeast Asia has its special bamboo vessels, many of which are unique to particular ethnic groups.

Household basketry consists of a wide range of vessels for storing, preparing, and serving food. Varying greatly in size, shape, strength, and permeability, they include baskets to hold dry food, closely woven narrow mouthed waterproof vessels, various plates and bowls, as well as trays. Many of these receptacles have been strengthened, waterproofed, preserved, and embellished by the addition of coatings of locally collected lacquer resin.

Split bamboo can be joined and interlaced in numerous ways. It can be coiled, twined, twisted, plaited, and woven in a variety of geometric and open weaves to best serve the purpose of the object being made. In Burma and northern Thailand (Lanna) several circular receptacles such as vases, bowls, votive vessels, and plates are made from coiled bamboo which is built up from 1-2 cm-wide strips which are notched at each end and hooked, one onto the other, to build the circular wall of a vessel. Some objects such as vases are sometimes first made in two or three separate parts and then carefully fitted together to complete the form. The base is coiled separately and later attached to the walls of the object. Sometimes wood instead of bamboo may be used for the base.

In the case of weaving small cups and bowls, the intended upright strips (warps) are first laid out flat in a circular crisscross fashion and interlaced with the weft to form the base. A wooden mandrel or chuck of the desired size and shape is attached to the base and mounted on a spindle. The bamboo warps are bent and pulled up and the weft is woven around them to form the sides of the bowl. The weft is also usually of bamboo of varying widths, depending on the size and intended use of the object.

Split bamboo can be woven in a variety of plain, twill and satin weaves to create sturdy flat sheets of matting which can be trimmed to the desired shape and size prior to being attached to a bamboo or wooden frame to form the substrate for larger items such as popular low circular meal tables, trays and larger boxes for clothing and personal grooming items. Instead of bamboo, rattan, a thorny climbing vine-like palm of the genus *Calamus* that grows wild in the rain forests of Southeast Asia may occasionally be used as a framework.

Wood
Small lidded boxes to store stationery, costume jewelry, and personal items, as well as trays, and stands made by carpenters are generally assembled from local softwoods. Elegant, gilded lacquer wooden pedestal stands are popular throughout mainland Southeast Asia for the offering of religious votive items and for the presentation and display of objects to persons of superior status. Low-footed wooden lacquered trays for tea and betel sets were popular items of hospitality.

Metal
According to the Pali *Vinaya* (Rules for Monks) alms bowls should be made either of clay or of iron. However, bowls may also be lacquered black or inset with mother-of-pearl decoration.

Paper, Palm Leaf, Cloth, Leather, and Clay
Masked dance dramas depicting Hindu epics such as the *Ramayana* are popular throughout Southeast Asia. Traditionally *papier-mache* made from the inner bark of the mulberry tree (*Broussonetia papyifera*) or from *khoi* (Siamese rough bush, *Streblus asper*) was used for the basic mask initially formed over a wooden or clay core. Once thoroughly dry, the mask was removed, and various distinctive facial details fashioned from wood, metal, molded lacquer, mother-of-pearl, and leather to "bring

to life" the character being represented. Mulberry, *khoi* paper, and palm leaf were also used for manuscripts that were embellished with lacquer-decorated covers. Folded cloth continues to be the leading substrate for the thickly lacquered unbound pages of Burmese *kammawa-sa* manuscripts. A clay core and cloth, as well as wooden and bamboo armature were important in creating Buddha images of dry lacquer in 19th century Upper Burma.

Preparing the Surface

Few substrates are ready for the final layers of lacquer without the addition of a necessary ground coating to fill and smooth out natural depressions between carved wood, woven interstices, joins and ridges from coiling and other construction processes. A number of different substances can be mixed with lacquer resin to apply a suitable undercoat for the substrate prior to the object receiving the final layers of best quality raw lacquer to impart a lustrous sheen characteristic of fine quality wares. Suitable additives range from finely ground clay to powdered ash and from any of the following: teak sawdust, cow dung, rice straw, dried palm leaves, and pulverized bone. The selected substance is carefully sifted through a cloth before being blended into the lacquer resin to form a smooth sticky paste that readily adheres to the substrate surface. After receiving the initial coating, the object is then placed to dry in a shaded area offering sustained warm moist conditions. The length of drying time is dependent upon the weather and can range from three to ten days. Once dry, the surface of the object may be further smoothed by rubbing with a light abrasive such as teak charcoal, ground fossil wood, dried leathery leaves, rice husks and water, or rubbing with a stone. For finer quality wares the coating, drying, and smoothing process may be repeated several times by applying an increasingly finer paste each time to ensure a perfectly even surface ready to receive the final coats of the highest-grade lacquer. The greater the number of applications, the better and more expensive the product due to the extra time, labor, and lacquer required.

Colorants

The naturally black lacquer resin may be colored for decorative purposes by the addition of pigments, usually applied by the artist responsible for embellishing the object. Artisans in different areas of Southeast Asia have their own special formulae for constituting various colors in lacquer, some of which are considered closely guarded secrets. Colors traditionally were made from ground-up pigments and were largely limited to red, yellow, brown, and orange. Blue and green were relatively rare in earlier lacquerware: these pigments were expensive or difficult to acquire or constitute.

Apart from black, the most widely used and most desired color for lacquer has been a vivid orange-red vermillion from cinnabar (mercuric sulphide) imported from China where it was first used to embellish lacquer over 3,000 years ago. In Pagan the powdered mercuric sulphide is dissolved in a little water before being added to lacquer resin and blended to a smooth consistency with a small amount of peanut or tung oil from the crushed seeds of *Aleurites fordii*. A lower-quality red ochre from

India is sometimes used if cinnabar is unavailable or too expensive. The interior of many lacquer vessels may be finished with red lacquer. Shades of brown may be produced by the addition of red pigment to black lacquer.

Yellow comes from orpiment (arsenic trisulphide) which is found south of Dali in Yunnan province, China and in Shan State, Burma. Since orpiment tends to flake, the finely ground powder is first mixed with a pellucid gum such as damar, a resin widely available in Southeast Asia from trees of the *Dipterocarpaceae* family. It may be applied as a powder or worked up with lacquer and a little tung or other plant-based oil. Orpiment may also be combined with cinnabar to make an orange hue which is also popular on lacquer. Thailand, Cambodia, and Laos have also used gamboge (a brownish-orange resin from the *Garcinia hanburyi* tree) in the lacquer process. The latex is collected in bamboo tubes where it solidifies and is later removed and pulverized for use as a pigment.

According to the late 19th and early 20th century literature on lacquer, blue was originally made from finely ground indigo which came from *Indigofera anil*, widely cultivated throughout Southeast Asia as an essential textile dye plant. Unfortunately the indigo did not combine well with the raw lacquer, resulting in a less desirable dull surface finish. One part indigo was added to orpiment to produce a muted green shade. During the colonial period the British in Burma expressed an interest in blue and green lacquer. Instead of indigo, the recently invented synthetic Prussian blue was used to produce a more easily rendered hue. It was also used in combination with orpiment to produce green. Continuing advances in chemistry during the late 19th and the 20th century led to the increasing availability of a whole range of new synthetic pigments such as vermillion, ultramarine blue, chrome green, and white from titanium dioxide, all of which are compatible with lacquer.

Gold leaf

The art of gilding religious and royal objects with tissue-thin squares of gold leaf is widely associated with the performing of a meritorious deed. Historically its use with respect to lacquer was largely limited to royalty and religious donations. Thailand, generally considered the leading exponent of this art form in Southeast Asia, has been reported as making gold-leaf decorated lacquerware (known as *lai rod nam*) since the 16th century. The technique at some point spread to the neighboring states of Burma, Laos, and Cambodia.

Methods of Decoration
Monochrome and Painted Wares

Fragments of basketry covered with brown lacquer and recovered from the 13th century Laymeythna temple at Pagan are possibly the earliest example of monochrome lacquer found in the region. Monochrome wares in red or black are ubiquitous while lacquer vessels with black exterior and red interior are also prevalent (**10**). The art of painted lacquer today does not appear to be widespread. Historically painted wares might have been more popular (**11**) but given the humid climate and voracious insect life, as well as periodic warfare, very little

PRODUCTION, USAGE, FORMS, AND DESIGN MOTIFS OF SOUTHEAST ASIAN LACQUERWARE

10 Three Burmese round bowls

11 A Burmese rectangular box

has survived. In each country there are a still a few artisans who produce painted lacquer, the designs of which appear to be simple and easily executed as seen on some Kyaukka, Cambodian, and Lao wares. Such embellishment continues to be popular on Lanna *khoen* lacquer which is noted for its rhythmic painted and stenciled floral and vegetal designs that fill the areas between the horizontal reinforced bamboo moldings that are a feature of *khoen* woven bamboo clothes and betel boxes (**12**). Gold leaf stenciled decoration on a red or black ground is popular on the supporting pillars, beams, and walls of Buddhist temples in Laos and in Shan State, Burma.

12 Three Lanna circular bowls

Incised Wares

Incised decorated lacquer is practiced in northern Thailand and at Pagan, Kyaukka and Laikha in neighboring Burma. Historically the art of lacquer in Burma and the former Lanna kingdom (1296-1556, centered in northern Thailand) has been linked via intermittent warfare and various tributary relationships. Experienced artisans who design the layout of pictorial subject matter are well-versed in Buddhist, Hindu, and local folklore and able to conjure traditional designs in a variety of styles and motifs from memory and without the aid of templates.

Incised wares from northern Thailand and Burma are characterized by lively freehand designs composed of rhythmic lines, dots, and dashes in red, yellow, green, and blue engraved with an iron stylus into a red, orange or black monotone lacquer ground (**13**). The design elements for each color are engraved separately and then completely covered over with lacquer mixed with the desired pigment

13 Three Burmese cylindrical betel boxes

14 Two Burmese gilded pedestal bowls

15 Three Burmese covered boxes in the form of fruit

16 A group of four Burmese gilded round boxes

which adheres to the incised lines. The article is then left for the lacquer to solidify for a few days. Once "set", the excess colorant is removed by polishing the object with wet rice husks, The object is returned to the cellar or cupboard to thoroughly dry before receiving an adhesive made from the resin of the neem (*Azadirachta indica*) or acacia tree (*Acacia farensiana*) which is painted over the newly made incisions to seal the pigment within the engraved lines. The first color to be applied to a design is usually red, followed by green. A new set of incisions is made, and the coloring, drying, and polishing sequence is repeated. The last colors to be applied in the same manner are yellow and orange. On Burmese work the top and the base of the main design may be framed by a series of concentric lines engraved with the aid of a compass. On completion, the entire design is completely sealed with a final coat of lacquer. After drying for a few days the object is polished to a lustrous sheen with rice husks, ground fossil wood or teak charcoal to bring out the beauty of the design. The interior of an object is usually finished with a coat of red, orange or brown lacquer. It can take around four to eight months to complete a fine piece of incised decorated lacquer which must pass through at least 25-30 distinct processes before being ready for use or offered for sale.

Embellishing with Gold Leaf

Lacquerware with gold leaf designs which is known by various names in Southeast Asia such as *lai rod nam* in Thailand and *shwe-zawa* in Burma has always been closely associated with royalty and religion. Although sumptuary laws forbade its everyday use amongst commoners, all were free to demonstrate their devotion to the Buddhist faith and gain merit by contributing to the gilding of images and temples and supplying the monkhood with their daily necessities often presented on distinctive gold-embellished receptacles (**14**).

As with most decorated wares, the surface of an object to receive a gold leaf design must first be carefully primed with one or two undercoats of a paste of powdered ash mixed with lacquer and finished with several coats of finest quality lacquer to ensure a perfectly smooth lustrous reflective surface to show the gold design to its best advantage. Simple gold designs may be directly drawn or painted on wet lacquer which is allowed to partially dry before the application of gold leaf or gold foil. Once completely dry, the excess fragments of gold leaf adhering to the design are carefully wiped away to reveal the design (**15**).

Paper patterns do not appear to have been generally used as artisans copied design elements from earlier examples that they admired. Gold leaf designs are usually drawn freehand on the lacquer surface with either a brush or a pen traditionally using a water-soluble solution of yellow orpiment mixed with neem gum.

Relief-molded Lacquer

When finished with gold leaf or gilt paint, this technique became popular for embellishing royal and religious furniture and architectural decoration (**16**).

The ingredients forming the underlying coating for *thayo* lacquer decoration in Burma – finely sifted ashes from cow dung, paddy husks or ground bone combined with lacquer – can be kneaded into a smooth thick pliant dough that can be readily drawn into long threads, pressed into metal or stone molds or deftly modeled freehand into various motifs to form two-dimensional relief patterns that when hardened and lacquered over, readily adhere to a variety of surfaces such as wood, basketry, paper, metal, and stone. The Thai and Lao make a similar very fine plastic-like substance known as *samut* from a fine vegetal ash from either banana leaves or from satin tail grass (*Imperata arundinacea*) combined with lacquer. Sometimes the dust of finely pulverized black earth may also be used. Cambodians also make a plastic substance from lacquer mixed with ash (*pheh*) made from burnt palm leaves or rice straw to which dammar, a dry brittle crystalline yellow resin (*chor chong*) obtained from trees of the Dipterocarpaceae family, might be added.

17 A Burmese gilded circular betel box on a matching pedestal stand, embellished with inlays of colored glass

Glass-Inlay

Throughout Southeast Asia much relief-molded embellishment on royal and religious halls and associated furniture such as shrines, preaching chairs, pulpits, screens, scripture chests, and votive objects has been further enhanced with inlays of colored glass mosaic (**17**). The colored glass to be used is cut with a glazier's diamond into various shapes and sizes to be inlaid according to the dictates of the design. The lacquer used for the imbedding process has been boiled down to a very thick consistency required for the task.

Shell Inlay

The use of shell for ornamentation in Southeast Asia dates to prehistoric times. Such early beginnings have contributed to Thailand becoming the region's leading exponent of the art of shell inlay, and by the late Ayutthaya and early Bangkok periods (c. 1757-1851), it was used to adorn temple doors, and windows, furniture, and royal and votive receptacles. Mother-of-pearl receptacles were also popular gifts from Thai kings to foreign dignities. Laos and Cambodia too were familiar with the techniques involved and practiced the art of shell or bone inlay on a smaller scale (**18**).

18 Three Thai or Cambodian mother-of-pearl rectangular boxes

Mother-of-pearl is the iridescent nacreous inner layer of certain mollusk shells formed from a crystalline calcium carbonate composed of aragonite platelets, biopolymers, and proteins that combine with an organic protein called conchiolin to form a durable lustrous substance. Rattan and woven or coiled bamboo are widely used as the foundation material for circular vessels.

The scenes or designs which are to embellish an object are sketched out in their entirety and then transferred in the reverse onto tracing paper. The naturally curved mother-of-pearl shell is cut into pieces averaging about 2.5 cm in size and honed on a whetstone until they are reasonably flat. Being brittle with a tendency to snap, the fragile fragments are temporarily glued to a wood backing. Once reinforced, the shell is cut into the desired shape with a curved bow saw. As cutting progresses, each piece of shell is pasted face-down into place on the design tracing.

The surface of the object to be decorated is initially given several separate coats of lacquer to create a base in which to set the mother-of-pearl. Before the final coat of lacquer is dry, the design mosaic of shell attached to the tracing paper is pressed face-down into the lacquered surface. Once the lacquer is completely dry the tracing paper is sprayed with water and then peeled away. Any remaining depressions and ridges between the newly placed shell fragments are filled with a paste made from pulverized charcoal mixed with lacquer. Once completely dry, the lacquer surface is sanded down with carborundum until it is completely smooth before being polished with a dried banana leaf infused with coconut oil.

Uses of Lacquer
Religious and Ceremonial

Lacquer has long served as the "glue" for much of the distinctive gilded carving and inlaid glass and shell decoration seen on imposing royal and Buddhist architecture. Some of the most beautiful temple doors were rendered in mother-of-pearl and glass inlay. Gold leaf and lacquer illustrations were popular for enhancing the interior faces of doors and window panels and for ceiling decorations stenciled in gold leaf on a red ground.

Buddha Images

The centrality of the Buddha in Theravada teachings is evident in the large number of seated and standing effigies of all different sizes in various media present at public shrines throughout the region (**19**). Images of marble, sandstone, metal or wood may be depicted either seated or standing with limbs arrayed in various positions, known as *mudras* for the hands and *asanas* for the feet, all of which have significance in the life of the Buddha. Using earlier Indian sculptures as models and treatises containing specifications for the manufacture of such effigies, by the 13th century talented artisans in local workshops throughout mainland Southeast Asia were producing distinctive Buddha images, some in lacquer, adapted to local preferences. The Burmans, Mon, Shan, Thai, Cambodians, and Lao all developed distinct styles of images that continued to evolve with the passage of time (**20**).

19 A small gilded Thai Buddha, with hands outstretched in calming the ocean posture, standing on an octagonal lotus base, 19th century

21 A Cambodian monk's alms bowl and cover

PRODUCTION, USAGE, FORMS, AND DESIGN MOTIFS OF SOUTHEAST ASIAN LACQUERWARE

Presentation of Gifts

Throughout Asia, the formal presentation of items to important personages, such as members of royalty, the nobility, and the highly revered monkhood, required designated receptacles (**21**). To meet this purpose, distinctive offering stands, bowls, and pedestal trays were developed, many of which were fashioned from wood and bamboo and intricately embellished with gilded lacquer and glass and shell inlay (**22**). At formal events members of royalty and their retainers were permitted the use of various vessels and utensils befitting the position granted them by the king. As emissaries of the Buddha, similar deference was accorded high-ranking ecclesiastics. Food, flowers, robes, candles, and incense sticks destined for monasteries were also offered in reserved vessels. Semi-formal presentations also functioned at a more mundane level in local transactions between inferiors and superiors, prospective in-laws, and potential business partnerships where gifts as tokens of appreciation, affirmation, or anticipation were part of the grist of everyday existence.

A number of historic temple reliefs and murals illustrate the use of special vessels in a variety of gift-giving rituals (**23**). In Cambodia a few such receptacles that appear on 10th century Khmer stone reliefs continue to be made today such as a waisted pedestal tray of lacquered wood inlaid with mother-of-pearl or painted with floral sprigs in red and gold used to present food and fruit offerings. A similar more rounded wooden pedestal bowl, covered with a domed lid surmounted by a knob for easy removal has also been in use since Khmer times. Known as a *dau*, today at weddings it may be filled with an assortment of banana leaf-wrapped 'fertility' cakes for distribution to guests. The red and gold painted designs on this vessel may resemble some of the textile patterns seen on Cambodian silk *ikat*.

Thailand possibly possesses the greatest variety of presentation receptacles, the most beautiful of which are of lacquered wood inlaid with mother-of pearl and colored glass (**24**). The most prevalent is a pedestal tray known as a *talum* most likely of Khmer origin, that comes in various sizes and may be used to present flowers,

20 A small Cambodian seated Buddha, hands folded in meditation, in red and black lacquer, 18th/19th century

24 A Thai mother-of-pearl pedestal tray

22 A diverse group of offering vessels and other objects

23 A group of four Cambodian offering vessels and monk's bowl

35

25 A Cambodian pedestal tray with conical-shaped lid

robes, and other gifts to the monkhood. It consists of a wide shallow tray, attached to a sturdy waisted stand that swells out to a base that is about two-thirds the width of the tray. It may be round, rectangular, hexagonal, octagonal, or dodecagon in shape. The sides can be straight, flaring, or curve slightly inward and may even resemble lotus petals. The rims and sides of a *talum* may occasionally be faceted while "corners" are generally rounded. However on some examples the sides may be concave or redented for added interest.

A smaller hourglass-shaped *talum* set upon a wider more traditional example becomes a two-tiered receptacle known as *pan wan-fah* used to present robes at *Kathina*, a month-long event at the conclusion of the Buddhist lent when the laity supply the monks with their basic necessities. Food brought to highly revered monks may be offered in a *tiab*, a receptacle with a wide *talum*-like base covered by a conical-shaped lid with redented corners. Such vessels also had a secular function: they could be used during marriage ceremonies to convey gifts to the bride's family or carry food to the bridegroom's house (**25**). A round smaller less elaborate bud-shaped vessel than the *tiab*, known as a *jiad*, was also used to bring food to a monastery. A circular box with a flat lid known as a *lung*, was also used to transport and store dry goods such as nuts, candies etc.

In Burma custom also decreed that ceremonial gifts to royalty and the monkhood should be tastefully arranged, humbly presented, and prominently exhibited on lacquered wooden or bamboo pedestal trays (**26**). Known as *kalat*, such vessels consisted of a wide shallow dish mounted on a flaring or runged pedestal. Heavier more substantial sized objects would be displayed on a *daung-lan*, a bigger more imposing version of the *kalat* which could be made completely of wood, or partially of wood and bamboo matting supported either by tall finely turned legs of wood or closely set rungs of bamboo.

The terms *daung-baung* and *kalat* used in combination, refer to another popular presentational receptacle for flowers and food items called *daung-baung kalat*, a wooden circular tray supported on small, splayed legs with a conical or domed cover to keep the contents fresh. In addition to monochrome red and black and polychrome lacquer, such receptacles may also be embellished with *yun* incised designs as well as gilded relief-molded lacquer inlaid with slivers of glass. The "feet" of some such vessels may be zoomorphic in the form of avian, reptilian, and leonine effigies popular in Burmese art. Paws and claws adapted from European sources also graced the base of some *daung-lan kalat* made during the colonial period.

With the demise of the Burmese monarchy in 1885, the former royal accoutrements of office such as vessels for betel paraphernalia, water bottles, bowls, and flower vases formerly in precious metals, were imitated by lacquer workers in gilded relief-molded lacquer and glass inlay for presentation to monasteries and pagodas mounted on wooden gilded *kalat* enlivened by a frill of gilded open-work sheet metal around the base of the tray. Such vessels could also be used as royal props in the festive "Great Renunciation" novitiation processions of joyous friends and relatives that accompanied a young man dressed up as a prince about to (temporarily) give up a comfortable lay existence to become a novice in the Buddhist sangha.

26 A Burmese circular pedestal tray

Black lacquered alms bowls, along with sets of robes, are the most popular requisites regularly offered by the laity to the monkhood. Thailand has some excellent examples of such bowls (*batra*) embellished with mother-of-pearl inlay, gold leaf, and northern Thai incised decoration. In Burma ceremonial bowls (*thabeik*) are usually embellished with gilded relief-molded lacquer decoration inlaid with slivers of colored glass. Similarly decorated large wooden ornate ceremonial fans and monumental flower vases have also been donated to monasteries and pagodas throughout the country.

27 A Burmese prayer manuscript with gilded covers

Preservation and Storage of Sacred Texts

Buddhist monks across mainland Southeast Asia were widely revered and respected for their erudition and explanations of sacred Theravada texts written in Pali on palm leaf. In addition to introducing the tenets of Buddhism, Buddhist monks sponsored the preservation and wider dissemination of religious and other knowledge by employing scribes using a needle or iron stylus to make faithful copies of important sacred texts as well as treatises on history, philosophy, astrology, astronomy, music, literature, law, medicine, and technology. On completion of a text, the inscribed palm leaves were stacked in order and placed between two lacquered wooden covers (**27**). A pair of small evenly spaced holes were drilled through the folios enabling string or bamboo pins to pass through the perforations to keep the leaves in order and secured to the covers. Religious texts and secular subject matter could also be transcribed in ink on accordion-style folding books (B: *parabaik*, T/L: *samut khoi*, K: *kraing*), a format that lends itself to illustrated narratives. Special editions prepared for the ecclesiastical hierarchy, royalty, and influential donors could be profusely illustrated, and finished with protective covers of superbly carved ivory, embossed silver and gold plate, niello, gilded relief-molded lacquer, and mother-of-pearl inlay. As highly esteemed works of merit created by an incredible attention to detail and painstaking labor, such manuscripts when not in use were wrapped in protective cloth covers secured by woven or braided ribbons into which was inserted a knife-shaped label inscribed with the title and folio numbers.

28 A Burmese gilded and footed manuscript box

Manuscripts pertaining to the Buddhist canon were also objects of veneration in their own right that needed to be carefully preserved from the potential depredations of a warm humid climate and a voracious insect life by storing them in solidly built teak cabinets and chests. Although some cabinets were rendered in polychrome painted lacquer, bas relief wood carving, and mother-of-pearl inlay, the overwhelming majority appear to have been superbly embellished with gold leaf and lacquer designs – featuring guardian figures, narrative and genre scenes set amongst foliage and fanciful landscapes, as well as traditional repetitive designs (**28**). Smaller lacquered boxes were used by monks for their notes and text when they delivered sermons away from the temple compound.

LACQUERWARE MASTERPIECES FROM SOUTHEAST ASIA

31 A Burmese round gilded *la-hpet* covered box

32 Three Burmese cylindrical betel boxes

include chicken or pork skin crackers, vegetable fritters, crispy insects, fried squid, and bowls of regional noodles, as well as glutinous and popped rice cakes, many of which in a casual setting tend to be served on ceramic ware rather than lacquer. In middle and upper class homes a variety of snacks might be served in Far Eastern-inspired circular lacquer snack boxes, the interior of which is subdivided into around six shallow wedge-shaped inserts surrounding a central hexagonal dish. In Burma where the use of lacquer receptacles remains popular, guests may be offered a snack of *la-hpet*, or pickled tea (chopped tea leaves soaked in brine mixed with sesame oil) along with fried garlic, roast beans and crickets, nuts, and dried shrimps served in a shallow circular segmented container with a rounded lid (**31**). At one time guests were also invited to smoke cheroots. They were presented with a large, segmented lacquer box containing a number of ingredients such as shavings of tobacco, star anise, flavor-infused wood chips, corn husk filters, and dried *thanat* leaf (*Cordia myxa*) for wrapping, to prepare a cheroot according to personal taste. Today cheroots offered are commercially made and kept in Western-inspired rectangular boxes, many of which are made of lacquer.

Throughout Southeast Asia for hundreds of years all sections of the population – royalty, the monkhood, artisans, and peasants regardless of sex, age and class – enjoyed the addictive, mildly euphoric pleasures of betel chewing. The essential components of a betel chew, including betel leaf, areca nut and lime, are all readily available throughout the region.

The sharing of betel traditionally fostered the bonding of relationships within the various segments and strata of South and Southeast Asian society. The betel set was also an indispensable insignia of office and social rank playing an important role in mainland Southeast Asian court ceremonies. Sumptuary laws decreed the size, design, extent of decoration and material permitted for betel boxes of the various grades of courtiers and the offer of a quid of betel to an underling from a royal betel set (or better still from royal lips) was considered a high honor.

The best-known lacquer receptacle in Burma is the cylindrical-shaped betel-box (*kun-it*), approximately 16 cm-20 cm high, made from woven bamboo and fitted with one or two shallow trays, the topmost of which holds small cups or boxes for the areca nut along with metal betel nut cutters, various preferred spices, and lime paste (**32**). A second tray might contain dried or shredded tobacco leaves, while betel vine leaves fill the remaining space below the trays. A deep cover with a slightly curved lid fits snuggly over the sides of the box to keep the contents fresh. The majority have been embellished with incised *yun* work on the lid and sides of the betel box and trays. In most cases the interior is finished in a black, red, or brown lacquer monochrome. Many boxes made during the colonial and postcolonial periods may carry inscriptions in Burmese on the base. Depictions of narrative scenes may also be identified by captions in Burmese. Larger boxes for communal use are around 20 cm high and up to 22 cm in diameter while betel boxes for personal use do not usually exceed more than 10 cm in height and 12-14 cm in diameter.

The Shan of eastern Burma also make bold, tiered, similarly shaped betel boxes embellished with lively executed incised designs in red on a black ground, occasionally highlighted with touches of gold paint (**33**). Square-shaped trapezoidal

boxes of wood or closely woven bamboo, inset with a snuggly fitting tray, with or without a matching cover, were also widespread in Shan State. Decoration consisted of narrow horizontal bands of geometric and stylized vegetal patterns painted in red on a black lacquer ground (**34**). The Karen in the borderlands separating Burma and Thailand make small sturdy woven betel boxes for personal use, the lid and base edges of which are reinforced by bands of natural bamboo scored by parallel lines and saw-tooth decoration that offer a pleasing contrast to the black lacquer exterior.

Burmese and Shan influences are also discernable with respect to some of the tiered cylindrical shaped betel boxes (*takra maak*) from the Lanna kingdom. However, with respect to those that resemble Burmese examples, the assemblage of trays may vary and usually consists of a sturdy ringed base that incorporates a comparatively shallow tray for betel leaves. A deeper tray bearing the supplementary ingredients of a betel chew fits snuggly over the base, followed by the shallow topmost tray containing slices of betel nut which is covered by a closely fitting regular lid. The sides and lid are embellished with bands of vegetal and floral decoration separated by narrow strips of geometric decoration painted in red on a black ground. With a decline in betel chewing, such boxes nowadays tend to be used for tobacco instead.

Most popular in northern Thailand are the two and three-tiered circular nesting trays of woven and coiled bamboo lacquered with ribbons of painted floral embellishment bounded by the usual rings of bamboo molding. Betel cutters and small tubular pestle and mortar pounders – utensils necessary for the preparation of a betel chew – are displayed in the topmost open tray which does not have a lid. Northern Thai lacquer artisans were previously also known to create a portable two-tiered betel box with a basket handle affixed to the rim of the topmost tier. Inside was a matching tray replete with a set of three to four small, matching covered boxes and a triangular betel leaf holder stocked with the essential ingredients of a betel chew that were arrayed atop the lid when in use.

One of the most unique and interesting of the betel boxes found amongst the minorities of upland Thailand and the borderlands of Laos is the form of a sturdy approximately 20 cm high by 25 cm wide square protruding box attached to a slightly smaller similar shaped stand made from remnants of plank wood that

33 A group of four Shan cylindrical betel boxes

34 Three Shan trapezoidal and rectangular open betel boxes

have been assembled with interlocking dove-tail type joins along the sides and reinforced with nails where necessary. Space in the box has been divided in half with one side being further subdivided into two or three sections to accommodate the ingredients and implements essential for a betel chew. The exterior of such boxes is usually lacquered and lightly incised or carved with shallow geometric patterns. The quality of the decoration varies greatly. The most striking and best-executed designs appear to be variants of the ancient Chinese interlocking "T" pattern. Some of the designs may be highlighted by touches of red lacquer and white paint or kaolin and occasionally shell inlay. Similar, better finished boxes with sloping sides and more sophisticated decoration have been attributed to Isaan in northeastern Thailand.

Circular wooden or woven bamboo lacquered boxes (*pro orb slar*), 10-12 cm high inset with a single matching tray subdivided into 3-4 sections, that were similar to those of Thai or hill tribe origin, were at one time widespread in Cambodia. Made in Kampong Thom Province where the lacquer tree is grown, betel has played a role in agrarian rituals and rites of passage since the early days of the Khmer empire in the 9th century. Betel references also abound in Khmer folklore and scholarly literature. Khmer lacquer boxes are distinctively embellished with bands of gold-painted floral rosettes on a black lacquer ground enlivened by touches of red. Designs may sometimes terminate in a series of vertical lines, a motif that is also present on Cambodian *ikat* textiles along with those from Isaan.

By contrast, betel boxes designed for religious and ceremonial use were more lavishly decorated. Throughout Southeast Asia those at the apex were permitted betel paraphernalia of exquisitely crafted repoussé-decorated gold and silver. In Thailand more distant royal relatives and high officials were permitted to own wooden lacquered betel boxes/trays with gold-leaf or mother-of-pearl embellishment. In Burma the most highly prized betel boxes were those embellished with gilded relief-molded designs enlivened with colored glass inlay which were presented as part of the permitted regalia of tributary Shan State princes. Similar more modestly decorated boxes were often presented by the laity to highly revered monks.

The Performing Arts

Lacquer has also been applied to masks made for dance dramas (**35**) featuring episodes from the *Ramayana*, a Hindu epic that was widely performed throughout Southeast Asia. Masks were at one time widely sculptured from local softwoods and finished with lacquer, gold leaf and various pigments. Most modern *Ramayana* masks in mainland Southeast Asia appear to be made from papier mâché pasted together with a rice powder glue over specially sculpted clay models or plaster casts based on the heads of actual performers. Once dry, the papier mâché mask is cut from the clay or plaster mold and rejoined. Since each mask is unique to a particular character, extra care is taken in the addition of ornamental details applied to headgear and to facial features such as "leaves" on the ears, protruding eyebrows, and various ridges surrounding the eyes and mouth. Many such features are formed from lacquer thickened by heating and mixing with pulverized ash, before being pressed into various small plaster molds. Once dry, such elements are removed from the molds

35 A pair of dancers in Burmese court costume, Burma, gold and lacquer on wood, elaborate costumes, decorated with colored glass

and glued to the mask, which is then painted and finished with gold leaf, sequins, and slivers of glass.

Design Motifs
Hinduism

Arriving in Southeast Asia via Indian trading networks during the early centuries of the Common Era, Hinduism has had a profound cultural effect on the region. The Khmer empire (802-1431) which held sway over much of mainland Southeast Asia was a Hinduized state that owed its prosperity to extensive hydraulic irrigation systems resulting in rice surpluses that indirectly furnished the means and manpower to construct many noteworthy temple complexes, built according to Indian principles of design and dedicated to major Hindu gods, such as Vishnu, and Shiva. The Hindu cult of the god-like *devaraja*, buttressed by Brahmanic rituals, was embraced by the Khmer kings who, through reincarnation beliefs, came to be indirectly associated with these two leading deities. By the 12th century the Khmer kings had also embraced Mahayana Buddhism and Hindu temples became places for Buddhist worship. By this time the kingdom was beginning a long slow decline.

36 A rectangular lacquer box cover, Burma, decorated with an elephant with attendants, with inscription, mid-20th century

The simpler, more direct Theravada Buddhist faith was making inroads with royalty and the population at large. Beset by devastating periods of drought and degraded irrigation systems, exacerbated by internal dissention and external strife with the neighboring states of Champa and the rising Thai kingdom of Ayutthaya, the Khmer finally abandoned Angkor in 1431 and moved south to Phnom Penh. Hindu elements in Thai and Laotian art have come largely through interactions with the Khmer.

Vishnu in particular has been associated throughout mainland Southeast Asia with power and righteous kingship. A widespread motif for modern Thailand is the *garuda*, a fierce half-man half-raptor, the mount of Vishnu, symbolizing strength, power, and protection. Depictions of this Hindu deity astride his *garuda* have appeared on carved, lacquered, and gilded wooden gable boards as well as in gold leaf painting and mother-of-pearl decoration on temple window shutters. The Hindu legend of the *garuda* locked in combat with a *naga* serpent, his mortal enemy, also appears on lacquer in Southeast Asian art. Throughout the region the sides of steps, bridges, and walkways to religious buildings may also be surmounted by a *naga* form or that of a mythical sea creature known as *makara*. *Naga* in Hindu mythology are regarded as guardians of the waters as well as symbols of fertility and abundance. In Laos and Cambodia *naga* are considered to have mythical ancestral connections with the living and may be woven on textiles to enhance protection.

Elephants, native to the region, occupy a special place in Southeast Asian art (**36**). The Hindu white multi-headed Airavata (T: Erawan) appears regularly on the gable boards of religious and public buildings in both Thailand and Laos. A triple-headed elephant sheltering under a seven-tiered-umbrella, serves as the logo

37 A Hanuman box, Cambodia, painted in red, green, blue and orange on wood

for Laos. The possession by a ruler of a white albino elephant, symbol of purity and good fortune portends prosperity for the kingdom. Southeast Asians are also familiar with effigies of Ganesha, the corpulent elephant-headed Hindu god of wisdom and remover of obstacles. The Burmese also honor images of Sarasvati (B: *Thuyathedi*), the Hindu goddess of knowledge and the arts. Small gilded carved wooden effigies of her riding on a *hamsa* bird (B: *hintha*) rather than a Brahmani goose or swan, are popular with students, writers, artists, and performers. Widely expressed in lacquer are both naturalistic and lively imaginative renderings of fauna, both real and composite, believed to be denizens of Himavanta (T: *Himmapan*), the legendary forest surrounding the base of Mt. Meru, the *axis mundi* of the Hindu-Buddhist universe. The ubiquitous Burmese lacquerware Eight Planets design (*gyo-hsit-lon*) featuring animals of the week (*garuda*, *naga*, two types of elephant, tiger, lion, rat, and guinea pig), associated with the cardinal and inter-cardinal directions, is based on elements derived from Hindu astrology. The zodiac design (*ya-thi*) also popular in Burma probably came via contact with India.

Ramayana

The famous Hindu epic ascribed to Valmiki, written between 400-200 BCE, relates the adventures of Rama, a virtuous young prince of Ayodhaya and avatar of Vishnu, whose beautiful wife Sita has been abducted by the evil ten-headed, twenty-arm Ravana, king of Lanka. Rama with the help of his steadfastly loyal brother Lakshmana, and the semi-divine monkey Hanuman (**37**) and his simian cohorts, fight many battles to rescue Sita. Allegorically, the epic highlights the eternal battle between good and evil and explores universal themes such as love, duty, honor, loyalty, and trust. The narrative is well known throughout Southeast Asia (K: R*eamker*, T: *Ramakien*, B: *Yama Zat*, and L: *Phra Lak Phra Ram*), and in some instances, it has been modified to incorporate local values and beliefs. It has served as an inspiration to many talented local writers, poets, painters, and artisans in their work, and various popular scenes from the epic are found on lacquer works throughout the region.

Buddhism

A widespread adherence to the Theravada faith has provided much of the subject matter for the didactic embellishment of architecture, furniture, and receptacles devoted to the religion (**38**). Familiar with such visual narratives since childhood, motifs and themes are instantly recognizable to most believers. Most widely depicted are the Eight Great Events that encapsulate the Buddha's life and teachings, beginning with the Nativity or birth from his mother's side, attaining Enlightenment under the bodhi tree, followed by the preaching of his First Sermon in a deer park at Sarnath, receiving the Gift of a Honeycomb from a Monkey, the Taming of the Nalagiri Elephant sent by Devadatta his evil cousin to kill him, Descent from the Tavatimsa Heaven where the Buddha went to preach to his mother, the Miracle at Sravasti where flames rise from his shoulders and water pours from his feet, as his image is replicated across the sky, and finally his death or *parinirvana*, heralding his entry into nirvana.

38 A Buddha head, Burma, dry lacquer, black lacquer and gold

Other events in the Buddha's biography that regularly appear in Southeast Asian Buddhist art include a series of events immediately preceding the enlightenment such as the Assault of Mara where the Meditating Buddha is attacked by the monstrous hordes of the Evil One. In this struggle the Buddha-to-be is decisively helped by Vasundhara the Earth Goddess (T: Phrae Mae Torani, B: Withundaye), who wrings out the water of the Buddha's previous donations to wash away the terrifying horde in the ensuing flood. Rivaling the depiction of the Eight Great Events in popularity, are representations of the 550 Jatakas that recount stories of the previous lives of the Buddha in divine, human, and animal form. Each narrative highlights a particular virtue to be emulated. The final Ten Jatakas, considered to be the most important, are the most frequently depicted. In Burma everyday objects such as bowls, trays and plates may be decorated with Jataka scenes in incised lacquer.

A number of Hindu entities and motifs have been co-opted and assimilated into the Buddhist universe. Ogres, demons, and door guardians of the former Hindu universe protect Buddhist monuments while former apsara (T: *Thepanom*, B: *nat*) with hands in praying mode serve as the welcoming devas of Buddhism. Inhabitants of the Himavanta forest also appear in Buddhism such as deer, elephants, and guardian lions including the *manussiha*, a double-bodied lion popular in Burma. Birds too have a special place in Buddhism. Particularly popular are *kinnari*, composite male and female creatures with the upper torso and head of a human combined with the wings and feet of a bird. The *naga* and other reptilian relatives from the subterranean realms are generally regarded as supportive of Buddhism. The lotus has long served as a seat, pedestal, or an accouterment for Hindu deities. It has become the most widely recognized emblem for Buddhism itself. Despite the roots being mired in the mud, the lotus flower that emerges above the water, perfect and undefiled, has long been a symbol of purity. A lotus in full bloom signifies enlightenment and spiritual growth. Bands of upward-facing or down-turned lotus petals are popular border motifs on Southeast Asian lacquerware.

Chinese Influence

With the exception of Vietnam and possibly Burma, Southeast Asian states have generally had long-standing cordial diplomatic and trading relations with China. Chinese from southern coastal provinces first sailed to Southeast Asia to trade, leading many to marry local women and settle permanently, eventually becoming dominant in commercial sectors throughout the region. Some also served as middlemen between the local population and China, then later provided a similar service to colonial interests. Disturbed conditions in China during the 19th century led to a further influx of Chinese migrants into Southeast Asia to avail themselves of economic opportunities offered by the colonial powers. Chinese tradesmen and skilled artisans proved themselves very adept at adapting to local art styles. They were active in woodcarving and silverware, but rarely in lacquer.

Chinese influences in Thai art were particularly notable during the reign of King Nangklao (Rama III, r. 1824-1851) who had during his father's reign overseen very profitable trading relations with China. Enamored of Chinese culture, numerous Buddhist temples built during the reign of Rama III show Chinese influence,

LACQUERWARE MASTERPIECES FROM SOUTHEAST ASIA

39 A betel box top, Burma, red lacquer background with zodiac figures within roundels

particularly with respect to the rendering of human and mythical figures, bamboo and flowering plants, gnarled trees, rocks and clouds, and the use of space in mural painting. Such innovations were also replicated in lacquer and gold-leaf painting on scripture cabinets and window shutters. The twelve animals of the zodiac (**39**), borrowed from the Chinese, is a popular motif depicted in mother-of-pearl and other lacquer.

While Burma's relationship with China at times has been somewhat more adversarial than Sino-Thai relations, cross-border trade has historically been important. Chinese influence inspired by ceramic forms is evident in some lacquerware shapes such as the tiered tiffin baskets made at Pagan and Kyaukka.

Western influence

After the abolition of the Burmese monarchy in 1885 many artisans, bereft of munificent royal patronage, found themselves out of work or suffering a severe loss of income, particularly in the former capital of Mandalay. Western influence began to infiltrate all forms of Burmese arts and crafts. Chubby winged putti culled from Christian religious prints, curling acanthus scrolling, roses, trumpet lilies, thistles, floral bouquets, arabesques, garlands and wreaths, flowing ribbons, bows, twisted rope, and beading became blended in with local motifs. By contrast humans depicted in lacquer narratives remained frozen in late Konbaung period costume, harking back as a reminder to when Burma was a self-governing independent kingdom.

Colonial occupation also created a new clientele for Burmese lacquer. British and other European residents as well as tourists were eager to purchase lacquer that complemented their Western lifestyles. Local lacquer artisans, eager to oblige, were soon making plates (**40**), chargers, soup tureens, fruit bowls, stem cups, mugs, teaspoons, trays, teapots, milk jugs, sugar bowls, cigar, cigarette and jewelry boxes, flower baskets, and gun cases embellished with Burmese and European motifs.

There was not as great Western influence on Thai, Cambodian, and Lao lacquerware which continued to offer the same forms, designs, and motifs as during the precolonial period.

Repetitive Motifs

Living in a warm tropical environment Southeast Asian art is well known for its wealth of closely patterned ornamentation that reflects the luxuriant abundance of local flora into which the natural and supernatural – gods, humans, and fauna, both real and imaginary – have been artfully placed and integrated into a coherent whole. Each country or region has a distinct way of expressing key motifs in lacquer that might offer clues to the likely origin and possible date of an object. Major designs are usually framed by narrower bands of repetitive ornamentation, many of which consist of various motifs arrayed within small rectangular, circular, diamond, or lozenge-shaped forms.

A very prevalent border and background pattern in Thai art is the *kranok*, a trailing, entwining, flickering triangular flame-like motif with many imaginative variants that may sometimes terminate in fabulous ogres, snake-like *naga*, bird's head, and animal masks. Other Thai designs include the *krajang* a funnel-shaped

40 A black lacquer plate, Burma, gold decoration with prancing horse in center

pointed leaf, which is often combined with smaller patterns to create a fringe effect along the lower edge of a design. The lotus bud-shaped *phum* and a more elongated equivalent, the *cho-hang* or rice ball design, may also provide space cells for other motifs such as praying *deva* (*thepanom*), and lion or ogre masks. Floral motifs abound and include the cotton flower (*lai bai thet*), a small daisy-like bloom (*lai dok phikul*), a four-petaled flower *(lai dok si klib)*, and hibiscus (*lai dok phuttan*). Bands of painted rhythmic floral and leaf decoration also predominate on lacquer from northern Thailand.

Burmese incised designs often appear against a densely patterned screen of curving red foliage-like decoration on a green hatch-stroke ground (*pan-bwa*) into which might be inserted small lively human, animal, and avian forms (*yok-thei*) that blend in so well as to be barely discernable at times. Interlocking cellular designs such as the Yunnan semi-circle design (*ku-nan kan*-byat), the Mt Meru (*myin-mo*), and the meandering *gwin-shet* pattern provide spaces for the placement of astrological and zoomorphic symbols representing the popular Eight Planets (*gyo-hsit-lon*) and zodiac (*ya-thi*) designs. On gold leaf *shwe-zawa* and relief-molded work border designs and floral scrolling are more prevalent than on incised work. The simplest border patterns consist of a zig-zag saw-tooth line and a wavy undulating line (*acheik*) from which may spring small comma-shaped hooks that appear to move closer together when the wavy line evolves into a coil-like form (*chu-pan*) to cover a larger area. Another popular related design includes a narrow meandering orchid pattern (*dha-zin-gwei*). A variety of foliage makes use of this basic wave and coil format that may unobtrusively open-up or bifurcate to make space for a flower-head, small animal or bird form. The more obvious geometric-shaped spaced cells, along with a popular lobed-shaped example known as *balu-gwin* also make use of *chu-pan* scrolling as a background filler.

Artisans of embroidery, woodcarving, and lacquer in Burma often like to fill right-angle corners of framed elements with an elaboration of a spade-shaped leaf-like ornament (*daung*). Relief-molded motifs may be further enlivened with glass inlay.

Detail of the side of mother-of-pearl box, Thailand or Cambodia

Bibliography

Adulyapichet, Apiwan, *Thai Lacquer Works*. Bangkok: Muang Boran Publishing House, 2012.

Bhirasi, Silpa, *Thai Lacquer Works*. Bangkok: The Fine Arts Department, 1962.

Byachrananda, Julathusana, *Thai Mother-of-Pearl Inlay*. Bangkok: River Books Ltd., 2001.

Capelo, Francisco, *A arte de Laca na Burmania e na Tailandia*. Lisbon: Instituto Portugues de Museus, 2004.

Clarke, John, "Highlights of the Lacquer Collection From Myanmar (Burma) in the Victoria and Albert Museum", *Arts of Asia*, vol. 47, no. 5, September-October 2017, pp. 46-62.

Conway, Susan, *The Shan: Culture, Arts and Crafts*. Bangkok: River Books Co., Ltd., 2006.

Fraser-Lu, Sylvia. "The Government Lacquer School and Museum of Bagan", *Arts of Asia*, vol. 16, no. 4, July-August 1986, pp. 68-74.

Fraser-Lu, Sylvia, *Burmese Lacquerware*. Bangkok, The Tamarind Press, 1985.

Fraser-Lu, Sylvia, *Burmese Crafts, Past and Present*. Kuala Lumpur: Oxford University Press, 1994.

Fraser-Lu, Sylvia, "Visual Narratives in Burmese Lacquerware", *Arts of Asia*, vol. 43, no. 3, May-June 2013, pp. 107-113.

Fraser-Lu, Sylvia and Sonia Krug. "Thai Mother-of-Pearl". *Arts of Asia*, vol. 12, no. 1, January-February 1982, pp. 107-113.

Fraser-Lu, Sylvia and Donald M. Stadtner (eds), *Buddhist Art of Myanmar*, New York: Asia Society Museum 2015.

Green, Alexandra (ed.), *Burma to Myanmar*, London: British Museum Press, 2023.

Isaacs, Ralph and Richard T. Blurton, *Visions from the Golden Land: Burma and the Art of Lacquer*. London: Art Media Resources Ltd., 2000.

Karow, O., *Burmese Buddhist Sculpture: The Johan Moger Collection*, Bangkok: White Lotus, 1991.

Kopplin, Monika (ed.), *Lacquerware in Asia, today and yesterday*. UNESCO Publishing, 2002 (https://unesdoc.unesco.org/ark:/48223/pf0000125890, accessed on 15 February 2024).

Lopetcharat, Somkiart, *Myanmar Buddha, The Image and Its History*, Thailand: Siam international Books Company Ltd., 2007.

Maspero, Georges, *Un empire colonial français, l'Indochine*. Paris et Bruxelles: Editions G Van Oest, 1929.

Miyazato, Masako, Rong Lu, Takayuki Honda, and Tetsuo Miyakoshi, "Lao Lacquer Culture and History: Analysis of Lao Lacquer Wares", *Journal of Analytical and Applied Pyrolysis*, 2013, 103: pp. 17-20.

Murphy, Stephen A. (ed.), *Cities and Kings: Ancient Treasures from Myanmar*, Singapore: Asian Civilisations Museum, 2016.

Panichphant, Vithi, *Lacquerware in Southeast Asia*. Chiang Mai: Art Sprout, 2015.

Singer, Noel, "Jengtung Lacquerware". *Arts of Asia*, vol. 21, no. 5, September-October 1991, pp. 154-158.

Singer, Noel, "Myanmar Lacquer and Gold Leaf: From the Earliest Times to the 18th Century", *Arts of Asia*, vol. 32, no. 1, January-February 2002, pp. 40-52.

Tagane, Shuichiro, Chika Kameda, Souphachay Phouphasouk, and Phetlasy Souladeth, "Gluta laosensis (Anacardiaceae), A New Species from Vientiane, Laos", *Phytotaxa* 2019, 415(3): pp. 153-156.

Than, Htun, *Lacquerware Journeys: The Untold Stories of Burmese Lacquer*. Bangkok: River Books, 2013.

Vadhanabhu, Narit, Kittisan Sriruksa, and Preechawut Apirating, "Gilt Lacquer Art in Luang Prabang: History and Cultural Diffusion", *Journal of Engineering and Applied Sciences*, 2019, 14(8): pp. 2553-2558.

Wenk, Klaus, *The Art of Mother-of-pearl in Thailand*. Zurich: Inigo von Oppersdorff, 1980.

Catalogue

The following catalogue comprises lacquer objects primarily from Burma, Thailand and Cambodia, with several pieces from Laos, all divided into nine discrete categories. This has been a surprisingly difficult and somewhat arbitrary undertaking as there is inevitably some overlap between, and even within, these broad categories.

A brief description of each piece is provided with an approximate date of manufacture, although this is often informed guesswork as dating of lacquerware is notoriously difficult. Although a country of origin is also provided for each piece, it is not possible to be entirely confident on this issue for some pieces. There is more certainty about Burmese lacquerware because this is a subject which has been more extensively researched, and there is a body of literature which provides helpful guidance on the lacquer production centers within Burma and dating. However, there is very little literature in English on the lacquerware of Cambodia, Laos and Thailand, although Professor Vithi's scholarship on the lacquerware of Southeast Asia has been most helpful in identifying some of the pieces in the collection, particularly those from Thailand and Cambodia. Some additional guidance on the country of origin of specific pieces has also been provided by some of the dealers who specialize in lacquerware from particular Southeast Asian countries.

Another factor making it difficult to determine the country of origin of some pieces has been the shifting borders of the countries of Southeast Asia, particularly in the 20th century, as well as cross-border mobility. For example, the Lanna Kingdom covered the north of Thailand, but at one time it also included northern Burma as well as the north of Laos, countries which share a similar artistic heritage, with similar forms and designs of lacquerware. In particular, Thai mother-of-pearl wares are often very similar in shape, form and design to certain Cambodian mother-of-pearl wares, while other mother-of-pearl pieces are distinctively Cambodian.

Rather than summarize the existing scholarship on the lacquerware in the collection, reference has been made to those books on the subject which illustrate many similar pieces. The following abbreviations have been used as references when similar objects to those in the collection have been found in these publications.

LJ	Lacquerware Journeys: the Untold Story of Burmese Lacquer, by Than Htun (Dedaye) (2013)
Isaacs	Visions from the Golden Land, Burma and the Art of Lacquer by Ralph Isaacs and T. Richard Blurton (2000)
BL	Burmese Lacquerware by Sylvia Fraser-Lu (2000)
MOP	Thai Mother-of-Pearl Inlay by Julathusana Byachrananda (2001)
Vithi	Lacquerware in Southeast Asia by Vithi Phanichphant (2015), translated by Narisa Chakrabongse
MB	Myanmar Buddha: the Image and its History by Somkiart Lopetcharat (2007)
BAM	Buddhist Art of Myanmar, edited by Sylvia Fraser-Lu and Donald M. Stadtner (2015)
BTM	Burma to Myanmar, edited by Alexandra Green (2024)
CK	Cities and Kings: Ancient Treasures from Myanmar, edited by Stephen A. Murphy (2016)
Karow	Burmese Buddhist Sculpture: The Johan Moger Collection by O. Karow (1991)

Baskets

LACQUERWARE MASTERPIECES FROM SOUTHEAST ASIA

01 Flower Basket

Burma, with shaped handle, black lacquer with red lacquer interior, early 20th century

W 29 cm, L 37 cm, H 33 cm
Reference: BL, pl. 5:80; Isaacs, pl. 123

BASKETS

02 Large Woven Basket

Burma, red lacquer over woven bamboo, ribbed sides, finely decorated rim, footed base, mid-20th century

W 17 cm, H 22 cm
Reference: BL, pl. 5:81

03 Tiered Sectional Basket

Burma, red lacquer over woven bamboo, early 20th century

W 27 cm, H 22 cm
Reference: BL, pl. 6:15

LACQUERWARE MASTERPIECES FROM SOUTHEAST ASIA

04 Round Ribbed Food Basket

Burma, red lacquer over coiled rattan, with cover, unusual form, early to mid-20th century

W 22 cm, H 22 cm
Reference: BL, pl. 6:19

05 Basket with Lid

Burma, Shan States, Inle Lake, round top tapering to square wood base, red and black lacquer over woven rattan, mid-20th century

W 39.5 (at top), H 39.5 cm
Reference: LJ, pls. 517, 521

06 Footed Basket

Cambodia, red and black lacquer over woven bamboo, standing on wooden feet, gold decoration

D 35.5 cm, H 18.5 cm
Reference: Vithi, p. 60

LACQUERWARE MASTERPIECES FROM SOUTHEAST ASIA

07 Footed Basket

Cambodia, food basket with conical cover, red and black lacquer over woven bamboo, mid-20th century

W 30 cm, H 45 cm

08 Round Ribbed Basket

Laos, sitting on square base, black lacquer on woven rattan, gold leaf decoration on interior and exterior surfaces, mid-20th century

W 31 cm, H 22 cm

09 Covered Basket

Laos, finely woven basket with cover, brown lacquer on woven rattan, gold decoration, mid-20th century

W 28 cm, H 13.5 cm

LACQUERWARE MASTERPIECES FROM SOUTHEAST ASIA

10 Pair of Footed Rice Baskets

Burma, Kengtung province bordering Thailand and Laos, black lacquer with raised gilded decoration, including human figures

Larger basket: D 22 cm, H 14.5 cm
Smaller basket: D 10.5 cm, H 13 cm
Reference: BL, pl. 7:28; LJ pls. 565, 566; BM, pl. 1.13

Inscription from bottom of larger basket (10)

BASKETS

11 Rice Basket

Laos, wide mouth tapering to narrow footed base, black lacquer exterior, gold leaf decoration around the rim, red lacquer interior

D 17 cm, H 10 cm
Reference: Vithi, p. 80

BASKETS

12 Small Covered Basket

Burma, red lacquer with relief decoration, domed cover, sitting on four feet

D 17.5 cm, H 11.5 cm,
early to mid-20th century
Reference: Isaacs, pl. 23

13 Large Covered Basket

Burma, ribbed food container, red lacquer over bamboo, bird-shaped feet, early 20th century

W 44.4 cm, H 26.7 cm
Reference: LJ, pl. 122

14 Wide Mouth Bamboo Basket

Burma, ribbed and lacquered, rim decorated with relief floral decoration inset with colored glass, early 20th century

W 40.5 cm, H 15.5 cm
Reference: LJ, pl. 122

15 Covered Basket

Burma, Shan States, Inle Lake,
red and black lacquer decoration,
four levels of turned supports,
early 20th century

D 33 cm, H 34.5 cm
Reference: LJ, pl. 519

Betel Boxes

16 Betel Box

Burma, orange decoration on green lacquer ground, early 20th century

D 14.6 cm, H 12.1 cm

17 Betel Box

Burma, orange and black lacquer, mid-20th century

D 22.7 cm, H 19.1 cm
Reference: Isaacs, pl. 54

Detail of 17 (top)

LACQUERWARE MASTERPIECES FROM SOUTHEAST ASIA

18 Betel Box

Burma, green and yellow decoration on black lacquer, late 20th century

D 16.4 cm, H 15 cm

Detail of 18 showing 2 interior trays

19 Betel Box

Burma, orange and green lacquer, early or mid-20th century

W 14.5 cm, H 12.8 cm
Reference: LJ, pl. 169

20 Betel Box

Burma, orange and green lacquer, with inscription, early or mid-20th century

D 19 cm, H 19 cm

LACQUERWARE MASTERPIECES FROM SOUTHEAST ASIA

21 Betel Box

Burma, unusual design,
early 20th century

D 14.5 cm, H 12.7 cm

Detail of 21 (top)

22 Betel Box

Burma, orange and green lacquer, early 20th century

D 22.2 cm, H 14.3 cm
Reference: LJ, pls. 169, 171

Detail of 22 (top)

LACQUERWARE MASTERPIECES FROM SOUTHEAST ASIA

23 Tall Betel Box

Thailand, Chiang Mai, floral design, late 19th or early 20th century

D 23.3 cm, H 19.5 cm
Reference: Isaacs, pl. 15; BM, pl. 3.9

24 Betel Box

Burma, orange and black lacquer, pendant floral decoration, early 20th century

D 14.4 cm, H 13 cm
Reference: BL, pl. 4:33, Isaacs, pl. 58

BETEL BOXES

25 Betel Box

Burma, green and orange lacquer, early 20th century

D 22 cm, H 20 cm

26 Betel Box

Burma, Pagan, orange lacquer with black decoration, second half 20th century

D 25.3 cm, H 22.5 cm
Reference: Isaacs, pl. 7

75

LACQUERWARE MASTERPIECES FROM SOUTHEAST ASIA

27 Betel Box

Burma, Pagan, zodiac signs within frames, early 20th century

D 22 cm, H 19.5 cm
Reference: LJ, pl. 172

Detail of 27 (top)

76

28 Betel Box

Burma, Pagan, figures set within frames, orange and green lacquer, mid-20th century

D 14.8 cm, H 12.7 cm

LACQUERWARE MASTERPIECES FROM SOUTHEAST ASIA

29 Betel Box

Burma, orange lacquer with scattered black abstract animals, mid or early 20th century

D 19.1 cm, H 16.8 cm
Reference: BL, pl. 4:29

Detail of 29 (top)

BETEL BOXES

30 Betel Box

Burma, red lacquer background with zodiac figures within roundels, mid-20th century

D 24 cm, H 22 cm
Reference: Isaacs, pl. 9

Detail of 30 (top)

79

LACQUERWARE MASTERPIECES FROM SOUTHEAST ASIA

31 Betel Box

Burma, orange and green lacquer,
court scene with attendants,
mid-20th century

D 22 cm, H 25 cm
Reference: BL, pl. 5:4

Detail of 31 (top)

BETEL BOXES

32 Betel Box

Burma, orange and black lacquer, dancing figure, mid-20th century

D 14.5 cm, H 12.5 cm
Reference: LJ, pl. 206

Detail of 32 (top)

LACQUERWARE MASTERPIECES FROM SOUTHEAST ASIA

33 Betel Box

Burma, orange and black lacquer, court scene with elephants and attendants, with inscription, mid-20th century

D 22 cm, H 12 cm

Detail of 33 (top)

34 Betel Box

Burma, court scenes with attendants, inscription on base, early 20th century

D 27.5 cm, H 26.5 cm
Reference: BL, pl. 5:4

Detail of 34 (top)

LACQUERWARE MASTERPIECES FROM SOUTHEAST ASIA

35 Betel Box Top

Burma, court scene with attendants, early to mid-20th century

D 26.6 cm, H 25.5 cm

Detail of 35 (side with inscription)

84

BETEL BOXES

36 Open Betel Box

Thailand, Chiang Mai, red and black lacquer, floral design, early 20th century

D 23.2 cm, H 18.6 cm

37 Pair of Similar Open Betel Boxes

Burma, early 20th century

Right: D 21.5 cm, H 13.4 cm;
Left: D 22.3 cm, H 13.3 cm
Reference: LJ, pl. 400

38 Open Betel Box

Burma, red and black lacquer, early to mid-20th century

D 20 cm, H 13 cm
Reference: LJ, pl. 400

39 Pair of Black Betel Boxes

Burma, black lacquer, decorated with red bands, mid-20th century

Left: D 10 cm, H 8.8 cm;
Right: D 13 cm, H 11.5 cm

BETEL BOXES

40 Betel Box

Burma, zodiac figures within stepped frames, orange and black lacquer, early 20th century

D 22.5 cm, H 19.5 cm
Reference: LJ, pl. 172; Isaacs, pl. 45

LACQUERWARE MASTERPIECES FROM SOUTHEAST ASIA

41 Betel Box

Burma, decorated with stylized animals, orange and green lacquer, early 20th century

D 22.3 cm, H 12.5 cm
Reference: BL, pl. 4:35

Detail of 41 (top)

BETEL BOXES

42 Betel Box

Burma, unusual bifurcated design on top, orange, yellow and black lacquer, early 20th century

D 15.5 cm, H 8.5 cm

Detail of 42 (top)

89

LACQUERWARE MASTERPIECES FROM SOUTHEAST ASIA

43 Betel Box

Burma, orange lacquer with green lacquer details on top and bottom, stylized animals on top and sides, early 20th century

D 22 cm, H 19.1 cm

Detail of 43 (top)

BETEL BOXES

44 Betel Box

Burma, orange and green lacquer, green details on top and bottom, early 20th century

D 19.7 cm, H 16 cm

45 Betel Box

Burma, minute yellow dotting over orange lacquer, mid-20th century

D 13.2 cm, H 9.7 cm
Reference: Isaacs, pl. 47

91

46 Betel Box

Burma, decorated with a design of eight planets arranged within interlocking grid pattern, inscription on lid, early 20th century

D 27.5 cm, H 16.5 cm
Reference: BL, pl. 4:14

Detail of 46 (top)

BETEL BOXES

47 Betel Box

Burma, eight zodiac signs within stepped frames, inscriptions on base and lid, early 20th century

D 16.7 cm, H 16.5 cm
Reference: BL, pl. 4.13

Detail of 47 (top)

93

LACQUERWARE MASTERPIECES FROM SOUTHEAST ASIA

53 Unusual Betel Box

Burma, Shan States, Laikha, gold leaf on black lacquer decorated with tantric figures and cabalistic designs, early to mid-20th century

D 16.5 cm, H 14.5 cm
Reference: LJ, pls. 438-441

BETEL BOXES

LACQUERWARE MASTERPIECES FROM SOUTHEAST ASIA

54 Open Betel Box

Burma, Chiang Mai, red and black lacquer, floral decoration, early to mid-20th century

W 31.8 cm, H 12.3 cm

55 Open Betel Box

Thailand, Chiang Mai, decorated with six stylized animals amidst floral decoration, late 19th century or early 20th century

D 28.3 cm, H 12 cm

56 Open Betel Box

Burma, black lacquer, red interior, early or mid-20th century

D 31.5 cm, H 13.5 cm

BETEL BOXES

57 Low Betel Box

Thailand, Chiang Mai, red and black lacquer, floral design, early 20th century

D 18.9 cm, H 7.5 cm

Detail of 57 (top)

LACQUERWARE MASTERPIECES FROM SOUTHEAST ASIA

58 Betel Box

Thailand, Chiang Mai, rare geometric design, early or mid-20th century

D 20 cm, H 9 cm

Detail of 58 (top)

59 Open Betel Box

Burma, yellow and green lacquer decoration, red interior, unusual design, mid-20th century

D 22.7 cm, H 16.7 cm
Reference: LJ, pls. 299, 300

102

BETEL BOXES

60 Tall Betel Box

Thailand, Chiang Mai, red and black lacquer, floral design, early or mid-20th century

D 19.7 cm, H 26.3 cm

61 Tall Betel Box

Thailand, Chiang Mai, red and black lacquer, unusual diamond design, early or mid-20th century

D 17 cm, H 20 cm

103

BETEL BOXES

62 Betel Box

Burma, unusual design,
early to mid-20th century

D 24 cm, H 15.6 cm

Detail of 62 (top)

63 Betel Box

Burma, orange decoration on
green ground, early 20th century

D 16.2 cm, H 13 cm
Reference: BL, pl. 3:13

105

LACQUERWARE MASTERPIECES FROM SOUTHEAST ASIA

64 Betel Box

Burma, eight zodiac animals, set within interlocking frames, orange and black lacquer, early to mid-20th century

D 26.5 cm, H 23.5 cm
Reference: LJ, pl. 4:4

Detail of 64 (top)

65 Betel Box

Burma, gold floral design on a black ground, unusual, early 20th century

D 16.7 cm, H 7 cm
See also p. 48

106

BETEL BOXES

66 Betel Box

Burma, unusual decoration, orange and green lacquer, early 20th century

D 21.9 cm, H 10.3 cm

Detail of 66 (top)

BETEL BOXES

67 Small Betel Box

Burma, black and red lacquer with gold highlights, detailed court scene, mid-20th century

W 28 cm, H 23 cm

Opposite page: Detail of 67 (side)

Detail of 67 (top)

LACQUERWARE MASTERPIECES FROM SOUTHEAST ASIA

68 Betel Box

Burma, orange, green and black lacquer, decorated with mythical figures and stylized animals, early 20th century

D 27.5 cm, H 24.5 cm
Reference: BL, pl. 4:8

69 Betel Box

Burma, decorated with scrolling metal wire covering entire box, unusual, early to mid-20th century

D 23 cm, H 24.5 cm

LACQUERWARE MASTERPIECES FROM SOUTHEAST ASIA

70 Betel Box

Burma, stylized animals, set within frames, unusual design, mid-20th century

W 19.5 cm, H 13.8 cm

Detail of 70 (top)

BETEL BOXES

71 Betel Box

Burma, red and black lacquer with gold highlights, unusual design with standing figures, possibly royal retinue, mid-20th century

W 22.7 cm, H 17.5 cm
Reference: LJ, pl. 161

Detail of 71 (top)

LACQUERWARE MASTERPIECES FROM SOUTHEAST ASIA

76 Tiered Betel Box

Burma, green and yellow lacquer decoration, stylized animals and courtiers, mid-20th century

D 16.4 cm, H 15 cm

BETEL BOXES

77 Large Betel Box

Burma, orange and green lacquer, unusual design, early to mid-20th century

W 31.5 cm, H 16 cm

Detail of 77 (top)

119

78 Small Betel Box

Burma, red and yellow lacquer on brown ground, mid-20th century

W 12.5 cm, H 10 cm

79 Betel Box

Burma, Shan States, Laikha, late 19th century

D 18.5 cm, H 16.5 cm
Reference: LJ, pl. 150

BETEL BOXES

80 Betel Box

Burma, Shan States, Laikha,
late 19th century or
early 20th century

D 26.2 cm, H 22.6 cm
Reference: LJ, pls. 413, 457

LACQUERWARE MASTERPIECES FROM SOUTHEAST ASIA

81 Sectional Betel Box

Burma, Shan States, Laikha, three sections, top and body lift to reveal storage trays, sides decorated with figures, top decorated with court scene, unusual

W 25.6 cm, H 22.3 cm

Detail of 81 (top)

BETEL BOXES

82 Three Small Circular Betel or Cosmetic Boxes

Burma, Shan States, late 19th or early 20th century

Left: D 12 cm, H 9 cm;
Rear: D 11.8 cm, H 6.7 cm;
Front: D 10.7 cm, H 5 cm
Reference: Isaacs, pl. 51

LACQUERWARE MASTERPIECES FROM SOUTHEAST ASIA

83 Three Small Betel Boxes

Burma, Shan States,
mid-20th century

Detail of 83 (bottom,
depicting cabalistic designs)
Reference: LJ, pls. 442–447

BETEL BOXES

84 Hexagonal Lacquer Tray with Small Betel Boxes

Tray: Cambodia, black lacquer on wood base, bamboo details, mid-20th century

Betel boxes: Burma, early to mid-20th century

85 Round Tray with Small Betel Boxes

Tray: Cambodia, red and black lacquer, bamboo details, mid to late 20th century

Betel Boxes: Burma, mid-20th century

Boxes

LACQUERWARE MASTERPIECES FROM SOUTHEAST ASIA

89 Rectangular Box

Thailand, with brass edging, top and sides covered with powdered minerals and crushed shell with iridescent characteristics

W 20.5 cm, L 31.3 cm, H 20.3 cm

BOXES

90 Rectangular Box

Thailand, black lacquer with bronze edging, decorative bronze cartouche inset in top and surrounding keyhole, early or mid-20th century

W 22.5 cm, H 13 cm, L 34 cm

91 Rectangular Box

Thailand, black lacquer, hinged top with bronze edging and decorative bronze inserts in top, mid-20th century

W 12 cm, H 9.8 cm, L 21.5 cm

LACQUERWARE MASTERPIECES FROM SOUTHEAST ASIA

92 Rectangular Box

Cambodia, beveled top, black and red lacquer, cover with carved red lacquer panel, early to mid-20th century

W 12.5 cm, L 23.5 cm, H 11 cm

Detail of 92 (cover)

132

BOXES

93 Rectangular Box

Cambodia, beveled top, black and red lacquer detailing, cover with carved red lacquer panel inset with mirror glass, early or mid-20th century

W 13 cm, L 24 cm, H 13 cm

Detail of 93 (cover)

133

LACQUERWARE MASTERPIECES FROM SOUTHEAST ASIA

94 Rectangular Box

Cambodia, black and red lacquer detailing, some gilding, cover with carved and gilded red lacquer panel, early or mid-20th century

W 11.2 cm, L 20.7 cm, H 11.5 cm

Detail of 94 (top)

95 Large Rectangular Box

Cambodia, beveled top, black lacquer with bamboo detailing, cover with carved red lacquer panel, some gilding and mica or mirror glass inserts, early or mid-20th century

W 18 cm, L 28.8 cm, H 14.5 cm

Detail of 95 (top)

LACQUERWARE MASTERPIECES FROM SOUTHEAST ASIA

96 Rectangular Box

Cambodia, beveled top, black lacquer with bamboo detailing, top with simple bone inlaid design, mid or late 20th century

W 14.5 cm, L 26 cm, H 11.2

97 Rectangular Box

Cambodia, black lacquer with beveled top, gold and red lacquer details, mid or late 20th century

W 15.5 cm, L 28.1 cm, H 13 cm

98 Rectangular Box

Cambodia, with indented corners, shaped top, black lacquer with gold details, early or mid-20th century

L 25 cm, W 13.5 cm, H, 14 cm

BOXES

99 Rectangular Box

Burma, Pagan, green lacquer decorated with gold dots, probably cheroot or cigar box, mid or late 20th century

W 21.2 cm, L 31 cm, H 11.5 cm
Reference: LJ, pl. 295

100 Rectangular Box

Thailand, Isaan region, black lacquer, bone edging and decorative bone inlay on top and sides, early or mid-20th century

W 16.6 cm, H 10.7 cm, L 29 cm

101 Gold Leaf Box

Burma, black lacquer with scrolling gold leaf decoration, hinged top, second half 20th century

W 22.8 cm, L 35.2 cm, H 12 cm

137

LACQUERWARE MASTERPIECES FROM SOUTHEAST ASIA

102 Tops of four Rectangular Boxes

All decorated with elephants and attendants

103 Rectangular Lacquer Box

Burma, red and black and red lacquer, decorated with elephants, probably for cheroots, mid or late 20th century

W 12 cm, L 17.5 cm, H 7 cm

BOXES

104 Rectangular Lacquer Box

Burma, decorated with monkeys, elephant and attendants on top, with inscription, mid-20th century

W 14.8 cm, L 23.8 cm, H 8 cm
Reference: Isaacs, pl. 146

105 Rectangular Lacquer Box

Burma, decorated with elephant with attendants on top, with inscription, mid-20th century

W 14.8 cm, L 23.8 cm, H 8 cm
Reference: Isaacs, pl. 146

Detail of 105 (top)

139

LACQUERWARE MASTERPIECES FROM SOUTHEAST ASIA

106 Rectangular Lacquer Box

Burma, decorated with elephants and attendants on top and sides, mid-20th century

W 7.8 cm, L 22 cm, H 7.2 cm

Detail of 106 (top)

BOXES

107 Large Rectangular Lacquer Box

Detailed decoration with chariots and figures, top with script inserts, early 20th century

W 29 cm, L 39.2 cm, H 13 cm
Reference: LJ, pl. 197

Detail of 107 (top)

141

108 Large Storage Box

Thailand, Sukhothai, black lacquer, molded decoration at top with coin in centre, possibly for tobacco, bamboo banding, mid-20th century

W 35.7 cm, H 19 cm

109 Large Storage Box

Cambodia, black lacquer with gold and red lacquer decoration, bamboo detailing, early 20th century

W 30 cm, H 19.5 cm

LACQUERWARE MASTERPIECES FROM SOUTHEAST ASIA

116 Oval Box

Cambodia, black and red lacquer with shaped top, inset with carved red lacquer panel, traces of gilding, early or mid-20th century

W 12.4 cm, L 24.5 cm, H 10.5 cm

Detail of 116 (top)

117 Oval Covered Box

Cambodia, shaped top, black lacquer with red decoration on top and sides, early or mid-20th century

W 14 cm, L 25 cm, H 11 cm

146

BOXES

118 Round Covered Box

Thailand, Chiang Mai, red and black lacquer, floral design, mid-20th century

W 16 cm, H 9.9 cm

119 Globular Round Box

Burma, red and green lacquer, unusual shape, mid-20th century

W 17.7 cm, H 14.5 cm

120 Round Box

Burma, red lacquer and bamboo, slightly convex top and bottom, late 19th or early 20th century

W 10 cm, H 17 cm
Reference: LJ, pl. 244

121 Cosmetics Box

Burma, possibly used for false hair tresses, red and orange lacquer with geometric design, mid-20th century

W 17 cm, H 13 cm

122 Round Box

Burma, gold decoration on black lacquer, floral design, mid or late 20th century

W 20.8 cm, H 11.3 cm, Reference: Isaacs, pl. 34

123 Four Small Round Boxes

Burma, black lacquer, entirely covered in gold, raised decoration, mid or late 20th century

From left: W 8-9.7 cm, H 6-10 cm; W 11.8 cm, H 6.7 cm; W 9.7 cm, H 6 cm; W 9.5 cm, H 6 cm

LACQUERWARE MASTERPIECES FROM SOUTHEAST ASIA

126 Two Black Lacquer Bowls

Thailand, each with cover, the larger bowl with bamboo bands, the smaller one with red lacquer interior

Larger bowl: W 38 cm, H 20.5 cm;
Smaller bowl: W 38 cm, H 18 cm

127 Black Lacquer Rice Bowl

Burma, with cover, red lacquer interior, mid-20th century

W 20.3 cm, H 13 cm
Reference BL, pl. 5:27

Detail of 127 (interior)

152

BOXES

128 Round Black Lacquer Box

Thailand, Sukhothai, storage box with shaped top, bamboo detailing, body slightly tapering, mid-20th century

W 22.2 cm, H 16.5 cm

129 Four Small Round Boxes

Burma (two boxes at rear), Cambodia, (two boxes in front), all black lacquer, one with woven rattan sides, another with bamboo details

130 Two Small Round Boxes

Cambodia, both with bamboo, decoration, mid-20th century

Left: W 9.5 cm, H 4.7 cm;
Right: W 11.8 cm, H 6.5 cm

153

LACQUERWARE MASTERPIECES FROM SOUTHEAST ASIA

131 Pair Similar Cosmetic Boxes

Burma, raised lid, orange lacquer with black decoration, early 20th century

Left: W 20.5 cm, H 16.5 cm;
Right: D 23 cm, H 17 cm
Reference: BL, pl. 5:66

132 Large Round Clothes or Storage Box

Burma, orange lacquer decorated with figures and animals set within stepped panels or frames, late 19th or early 20th century

D 42 cm, H 34 cm
Reference: Isaacs, pl. 44 (similar decoration)

133 Large Storage Box

Burma, orange, black and yellow lacquer, geometric design, early 20th century

D 41.5 cm, H 21.4 cm

134 Three Cosmetic Boxes

Burma, each a similar size but of varying designs, often used for the storage of false tresses, early or mid-20th century.

W 17 cm, H 15 cm
(all of similar dimensions)
Reference: BL pl. 5:66

139 Large Food Container Containing Covered Bowls

Thailand, red lacquer with floral design, interior tray with five covered lacquer tea or rice bowls, early 20th century

W 41 cm, H 25 cm

BOXES

Detail of 139 (top)

Detail of 139 (interior)

Mother-of-Pearl and Bone Inlay

LACQUERWARE MASTERPIECES FROM SOUTHEAST ASIA

140 Five Offering Trays of Varying Sizes

Thailand or Cambodia, each with concave corners and inlaid with mother-of-pearl and/or mirrored glass

Reference: Vithi, p. 56

MOTHER-OF-PEARL AND BONE INLAY

141 Offering Tray

Thailand or Cambodia, square tray with concave corners, mother-of-pearl decoration with black lacquer panel on each side, possibly for intended inscription, mid-20th century

W 27 cm, H 10 cm

142 Square Offering Tray

Thailand or Cambodia, black lacquer with gold decoration and bone and shell inlay, hardwood rim, mid-20th century

W 28.2 cm, H 8.2 cm

143 Offering Tray

Thailand or Cambodia, square tray with concave corners, red lacquer decoration, mid-20th century

W 25.4 cm, L 25 cm, H 8 cm

163

LACQUERWARE MASTERPIECES FROM SOUTHEAST ASIA

144 Offering Tray

Thailand or Cambodia, with concave corners, inlaid with mother-of-pearl and bone, red lacquer interior, late 19th to early 20th century

W 27.3 cm, L 27.7 cm, H 7.8 cm
Reference: Vithi, p. 56

145 Offering Tray

Thailand or Cambodia, with indented corners, inlaid with mother-of-pearl and glass with red lacquer interior, late 19th to early 20th century

W 19 cm, L 19 cm, H 5 cm
Reference: Vithi, p. 56

146 Offering Tray

Thailand or Cambodia, with concave corners, inlaid with mother-of-pearl, scrolling design, brown lacquer interior, late 19th to early 20th century

H 30 cm, L 30 cm, H 10.7 cm
Reference: Vithi, p. 56

MOTHER-OF-PEARL AND BONE INLAY

147 Offering Tray

Thailand or Cambodia, with concave corners, inlaid with mother-of-pearl, red lacquer interior, late 19th to early 20th century

W 29.5 cm, L 31 cm,
H 11.5 cm
Reference: Vithi, p. 56

148 Offering Tray

Thailand or Cambodia, with concave corners, inlaid with mother-of-pearl, red lacquer interior, late 19th or early 20th century

W 23.5 cm, L 23.5 cm, H 7.5 cm

165

LACQUERWARE MASTERPIECES FROM SOUTHEAST ASIA

152 Offering Tray

Thailand, with concave corners, inlaid with mother-of-pearl and mirror glass, traces of original red lacquer interior, late 19th or early 20th century

W 30.5 cm, L 31 cm, H 9 cm

153 Square Offering Tray

Thailand, square corners, inlaid with mother-of-pearl and mirror glass, red lacquer interior, bun feet, late 19th to early 20th century

W 29 cm (square), H 11 cm

168

MOTHER-OF-PEARL AND BONE INLAY

154 Square Betel Tray

Thailand, square tray with three compartments, inlaid with mother-of-pearl, red lacquer interior, early 20th century

W 19.5 cm (square), H 13 cm
Reference: Thai MOP, p. 147

155 Three Rectangular Boxes

Thailand or Cambodia, rectangular boxes of varying sizes, each with beveled lid, all inlaid with mother-of-pearl, late 19th or early 20th century

Largest: W 21.3 cm, L 22.2 cm, H 13 cm

169

LACQUERWARE MASTERPIECES FROM SOUTHEAST ASIA

Detail of 156 (side)

156 Rectangular Box

Thailand or Cambodia with beveled lid, inlaid with mother-of-pearl, red lacquer details, late 19th or early 20th century

W 10.2 cm, L 19 cm, H 11 cm

MOTHER-OF-PEARL AND BONE INLAY

157 Rectangular Box

Thailand or Cambodia, mother-of-pearl decoration, early 20th century

W 6 cm, L 12 cm, H 5 cm

158 Rectangular Box

Thailand or Cambodia, with beveled lid, inlaid with mother-of-pearl, late 19th or early 20th century

W 12.2 cm, L 22.3 cm, H 13 cm

Detail of 158 (top)

Pages 172-173: Detail of 158 (side)

171

LACQUERWARE MASTERPIECES FROM SOUTHEAST ASIA

159 Rectangular Box

Thailand, black lacquer with
inlaid mother-of-pearl,
scroll design, mid-20th century

W 10.4 cm, L 16 cm, H 7 cm
Reference: Thai MOP, p. 138

Detail of 159 (top)

174

MOTHER-OF-PEARL AND BONE INLAY

Detail of 160 (side)

160 Rectangular Box

Thailand, black lacquer with inlaid mother-of-pearl, mid-20th century

W 12.2 cm, L 23.5 cm, H 13 cm

175

LACQUERWARE MASTERPIECES FROM SOUTHEAST ASIA

161 Rectangular Box

Thailand, black lacquer with
inlaid mother-of-pearl,
mid to late 20th century

W 13.3 cm, L 19.7 cm, H 8.5 cm

Detail of 161 (top)

MOTHER-OF-PEARL AND BONE INLAY

162 Large Rectangular Box

Thailand or Cambodia, black lacquer, inlaid with mother-of-pearl, pictorial design with birds in trees, fish in the sea, late 20th century

W 20.5 cm, L 35.5 cm, H 15.5 cm

Detail of 162 (top)

LACQUERWARE MASTERPIECES FROM SOUTHEAST ASIA

167 Pedestal Tray

Thailand, black lacquer inlaid with mother-of-pearl, early 20th century

W 19.3, H 13.5 cm

168 Round Offering Tray

Thailand, black lacquer inlaid with mother-of-pearl, red lacquer interior, early 20th century

W 26 cm, H 10 cm,
Reference: Thai MOP, p. 96

169 Alms Bowl Cover

Thailand, black lacquer inlaid with mother-of-pearl, foliate design with birds, early 20th century

W 29.5 cm, H 8 cm

Detail of 169 (top)

LACQUERWARE MASTERPIECES FROM SOUTHEAST ASIA

170 Alms Bowl Cover

Thailand, black lacquer inlaid with mother-of-pearl, unusual floral design, early 20th century

W 30 cm, H 8 cm

Detail of 170 (top)

MOTHER-OF-PEARL AND BONE INLAY

171 Alms Bowl Cover

Thailand, black lacquer inlaid with mother-of-pearl, central medallion with mythical animal, early 20th century

W 29 cm, H 8 cm

172 Stand

Cambodia, black lacquer inlaid with mother-of-pearl, floral design, mid-20th century

W 7.5 cm, L 19 cm, H 13.7 cm

LACQUERWARE MASTERPIECES FROM SOUTHEAST ASIA

179 Traveling Betel Box

Thailand, Isaan region,
black lacquer inlaid with bone,
early or mid-20th century

W 19.5 cm, H 19 cm
Reference: Vithi, pp. 34, 140

Detail of 179 (top)

MOTHER-OF-PEARL AND BONE INLAY

180 Traveling Betel Box

Thailand, Isaan region, black lacquer with bone inlay, early or mid-20th century

W 15.4 cm, H 14.8 cm
Reference: Vithi, pp. 34, 140

Detail of 180 (top)

189

LACQUERWARE MASTERPIECES FROM SOUTHEAST ASIA

183 Traveling Betel Box

Thailand, Isaan region,
black lacquer with bone inlay,
early or mid-20th century

W 16.4 cm, H 16.1 cm
Reference: Vithi, pp. 34, 140

Detail of 183 (top)

MOTHER-OF-PEARL AND BONE INLAY

184 Traveling Betel Box

Thailand, Isaan region,
black lacquer with bone inlay,
early or mid-20th century

W 15.3 cm, H 15.5 cm
Reference: Vithi, pp. 34, 140

Detail of 184 (top)

193

Pedestal Stands

LACQUERWARE MASTERPIECES FROM SOUTHEAST ASIA

185 Offering Stand

Burma, Shan States, Inle Lake, red lacquer, turned wooden supports, mid-20th century

D 28 cm, H 16 cm
Reference: Isaacs, pl. 107

186 Two Small Offering Stands

Thailand, black lacquer with basketry sides, red lacquer tops, mid-20th century

Left: W 24.5 cm, H 12 cm;
Right: W 23 cm, H 14 cm

PEDESTAL STANDS

187 Offering Stand

Thailand, Chiang Mai, incised floral decoration, red and black lacquer, early 20th century

W 27 cm, H 27 cm
Reference: LJ, pl. 14

Detail of 187 (side)

LACQUERWARE MASTERPIECES FROM SOUTHEAST ASIA

188 Offering Bowl Stand

Burma, raised and gilded decoration, red lacquer interior, mid-20th century

W 19 cm, H 11 cm

189 Offering Bowl Stand

Cambodia, black lacquer with red lacquer accents and gold dot decoration, bamboo detailing, early 20th century

W 6 cm, H 10 cm

PEDESTAL STANDS

190 Pedestal Stand

Burma, red and black lacquer on wood, turned wood supports, early or mid-20th century

W 28 cm, H 16 cm
Reference: BL, pl. 6:22

191 Offering Stand

Thailand, Chiang Mai, gold leaf on red lacquer, turned wood supports, early 20th century

D 32 cm, H 23 cm

LACQUERWARE MASTERPIECES FROM SOUTHEAST ASIA

192 Offering Stand

Burma, Shan States, red lacquer with open basketwork, early 20th century

D 33 cm, H 21 cm
Reference: LJ, pls. 502, 503

Detail of 192 (top)

200

PEDESTAL STANDS

193 Offering Stand

Burma, wood, inlaid with colored glass and mirror glass, red lacquer interior, mid-20th century

D 30 cm, H 24.5 cm

LACQUERWARE MASTERPIECES FROM SOUTHEAST ASIA

198 Offering Bowl Stand

Cambodia, refined gold and red decoration on black lacquer, dated 1920

D 21 cm, H 13.4 cm

PEDESTAL STANDS

199 Large Offering Stand

Cambodia, refined gold
and red decoration on
black lacquer with
central medallion,
early to mid-20th century

W 46.2 cm, H 22.8 cm

Detail of 199 (medallion)

205

Plates, Trays, Bowls and Cups

LACQUERWARE MASTERPIECES FROM SOUTHEAST ASIA

200 Three Round Fluted Rice Bowls

Burma, Kyauktan, different sizes, black lacquer with red interior

Reference: BL, pl. 5:27; LJ, pl. 287

201 Pair of Round Rice Bowls

Burma, one with raised gilded decoration around the rim, probably for ceremonial use, both black lacquer with red lacquer interiors, mid-20th century

Left: W 24.5 cm, H 13 cm;
Right: W 26 cm, H 13 cm
Reference: BL, pl. 5:27

208

PLATES, TRAYS, BOWLS AND CUPS

202 Ceremonial Bowl

Burma, with gilded raised lacquer decoration, mid-20th century

W 21 cm, H 12.5 cm

203 Ceremonial Bowl

Burma, raised lacquer decoration, gilded, red lacquer interior, early or mid-20th century

W 21 cm, H 12.5 cm

209

LACQUERWARE MASTERPIECES FROM SOUTHEAST ASIA

207 Offering Bowl on Stand

Cambodia, black lacquer with bamboo decoration, early or mid-20th century

W 24 cm, H 23 cm

208 Offering Bowl

Cambodia, bowl in separate fitted stand, both with bamboo decoration, mid-20th century

W 24 cm, H 23 cm

212

PLATES, TRAYS, BOWLS AND CUPS

209 Bowl

Cambodia, black lacquer with red lacquer band around the rim, bamboo detailing and gold decoration, early 20th century

W 22.3 cm, H 13.4 cm

210 Offering Bowl

Cambodia, with refined red and gold decoration, bamboo decoration around the lip, early 20th century

W 20.5 cm, H 12 cm

213

LACQUERWARE MASTERPIECES FROM SOUTHEAST ASIA

211 Small Cup

Thailand, red lacquer with simple floral decoration, mid-late 20th century

W 11.1 cm, H 7.8 cm

212 Lacquer Cup

Thailand, flat sided cup with red and black lacquer floral design, mid-20th century

W 6 cm, H 5 cm

213 Footed Cup

Burma, red and black lacquer decorated with mythical creature, inscription, mid-20th century

W 12 cm, H 10 cm

PLATES, TRAYS, BOWLS AND CUPS

214 Cup

Burma, red, green and black lacquer, court scene, with inscription, mid-20th century

W 11.1 cm, H 8.5 cm

215 Footed Bowl

Burma, red, black and green lacquer, court scene with figures, mid-20th century

W 25 cm, H 26 cm

215

216 Footed Bowl

Burma, orange lacquer,
mid-20th century

W 14 cm, H 10.3 cm
Reference: BL, pl. 5:29

217 Cup

Burma, orange and green lacquer,
rounded base, mid-20th century

W 19.2 cm, H 7.5 cm

PLATES, TRAYS, BOWLS AND CUPS

218 Footed Bowl

Burma, orange and black lacquer, decorated with figures in court scene, with inscription, early to mid-20th century

W 24.2 cm, H 20.5 cm
Reference: Isaacs, pl. 62

Detail of 218 (side)

217

219 Footed Bowl

Burma, orange lacquer, supported on six legs, mid-20th century

W 19.5 cm, H 12.5 cm

220 Two Footed Cups

Burma, both gilded, one with raised design, the other with black script around the sides of the cup, mid to late 20th century

Left: W 13.4 cm, H 10.4 cm;
Right: W 13.2 cm, H 10.6 cm

PLATES, TRAYS, BOWLS AND CUPS

221 Round Shallow Rice Tray

Burma, Shan States, Inle Lake, red and black lacquer, mid-20th century

W 43.3 cm, H 2.5 cm
Reference: LJ, pl. 522

222 Round Shallow Rice Tray

Burma, red and black lacquer, central decoration, mid-20th century

W 54.5 cm, H 5.5 cm
Reference: Isaacs, pl. 138

223 Oval Plate

Thailand, shaped edges, red lacquer over black, floral design, mid-20th century

W 285 cm, H 4 cm

219

LACQUERWARE MASTERPIECES FROM SOUTHEAST ASIA

229 Square Tray

Cambodia, red lacquer decoration over black lacquer, early 20th century

D 22.5 cm, H 9 cm

230 Round Betel Tray

Cambodia, four compartments, refined gold decoration on black and red lacquer, bamboo details, mid-20th century

D 22.8 cm, H 12.5 cm
Reference: Vithi, p. 56

PLATES, TRAYS, BOWLS AND CUPS

231 Square Open Betel Box

Burma, Shan States, Inle Lake,
tapered, red decoration on black,
early 20th century

D 17 cm, H 22.5 cm
Reference: LJ, pl. 493

232 Square Open Betel Box

Burma, Shan States, Inle Lake,
red and black lacquer decoration,
early 20th century

D 28.5 cm, H 23.5 cm
Reference: LJ, pl. 493

LACQUERWARE MASTERPIECES FROM SOUTHEAST ASIA

233 Round Betel Tray

Cambodia, with four compartments,
red floral decoration on black
lacquer, bamboo details,
mid-20th century

D 22.8 cm, H 11.2 cm

PLATES, TRAYS, BOWLS AND CUPS

234 Square Betel Tray

Cambodia, red lacquer and gold decoration on black lacquer, unusual form, early 20th century

D 22 cm, H 16 cm

235 Multi-sided Betel Tray

Cambodia, red decoration on black lacquer with bamboo details, unusual design, early 20th century

D 26.5 cm, H 10.5 cm

225

240 Round Betel Tray

Cambodia, with four compartments, gold decoration on black lacquer, bamboo details, early or mid-20th century

D 22.5 cm, H 12.5 cm
Reference: Vithi, p. 56

241 Betel Tray

Cambodia, concave corners, red decoration on black lacquer, bamboo detailing, early or mid-20th century

D 25 cm, H 8 cm

PLATES, TRAYS, BOWLS AND CUPS

242 Round Betel Tray

Cambodia, with four compartments, red and black lacquer, bamboo details, early to mid-20th century

D 24.6 cm, H 11.3 cm

243 Round Betel Tray on Octagonal Base

Cambodia, with four compartments, sitting on octagonal base, gold decoration on black lacquer, bamboo details, mid-20th century

D 21.2 cm, H 21.5 cm
Reference: Vithi, p. 56

229

LACQUERWARE MASTERPIECES FROM SOUTHEAST ASIA

244 Round Shallow Betel Tray

Cambodia, red and black lacquer, bamboo details, second half 20th century

D 31.5 cm, H 8 cm

245 Round Shallow Betel Tray

Cambodia, red and black lacquer with gold decoration, central medallion, second half 20th century

D 32 cm, H 6 cm

246 Round Shallow Betel Tray

Cambodia, black lacquer with bamboo decoration, second half 20th century

D 30.7 cm, H 6 cm

PLATES, TRAYS, BOWLS AND CUPS

247 Square Open Betel Tray

Thailand, Isaan region, no interval divisions, black lacquer exterior with decorative bone inlay

W 22.5 cm, H 19.8 cm, (at base)
Reference: Vithi, p. 140

231

LACQUERWARE MASTERPIECES FROM SOUTHEAST ASIA

248 Square Open Betel Tray

Thailand, Isaan region, no internal divisions., decorative carving on red lacquer, early 20th century

W 21 cm, H 21 cm

249 Footed Round Tray

Burma, Shan States, open tray on raised platform, gold decoration on red and black lacquer, early or mid-20th century

W 31 cm, H 12.5 cm

232

PLATES, TRAYS, BOWLS AND CUPS

250 Octagonal Tray

Cambodia, plain black lacquer, black decoration, tray with bamboo decoration, mid-20th century

W 25 cm, H 11.3 cm

251 Covered Round Box

Burma, for candies or condiments, gold leaf decoration on black lacquer, late 20th century

W 25 cm, H 7 cm

233

Religious Items

LACQUERWARE MASTERPIECES FROM SOUTHEAST ASIA

252 Ceremonial Monk's Bowl

Burma, Shan States, covered monk's bowl on a stand, both embellished with molded lacquer decoration, gilded and decorated with colored glass, early 20th century

W 25.4 cm, H 36.5 cm
Reference: BL, pl. 6:6

Detail of 252 (cover)

RELIGIOUS ITEMS

253 Ceremonial Betel Box

Burma, Shan States, betel box on a stand, embellished with molded lacquer decoration, gilded and decorated with colored glass, early 20th century

W 27.5 cm, H 36.5 cm
Reference: BL, pl. 6:34

Detail of 253 (top)

LACQUERWARE MASTERPIECES FROM SOUTHEAST ASIA

254 Pair of Heavily Gilded Ornamental Stands

Burma, each with domed top, supported by mythical animals on square base, gilded and decorated with colored glass, early 20th century

W 17 cm, H 90.4 cm
Reference: BL, pl. 6:30

RELIGIOUS ITEMS

255 Pair of Fans

Burma, scalloped edges with peacock in center, gold and red lacquer decorated with colored glass, each fan with date in Burmese script, early 20th century

W 40.5 cm, D 8 cm
Reference: BL, pl. 6:27

Detail of 255 (single fan)

239

LACQUERWARE MASTERPIECES FROM SOUTHEAST ASIA

256 Alms Bowl with Cover

Cambodia, black lacquer with bamboo detailing, sitting on woven bamboo stand, black with red lacquer decoration, mid or late 20th century

W 23.5 cm, H 27.5 cm (with stand)

RELIGIOUS ITEMS

257 Rectangular Storage Box or Qur'an Chest

Burma, Islamic star and crescent embossed on top, possibly intended for export market, molded decoration with colored glass, late 19th or early 20th century

L 44.2 cm, H 29.3 cm
Reference: Green, pl. 3:14

Detail of 257 (top)

260 Manuscript Box

Burma, gilded with fine open work carved decoration, with carved lion feet, gold leaf, stand

W 33.5 cm, L 74.5 cm, H 27.8 cm
Reference: BL, pl. 6:47

Detail of 260 (side panel)

LACQUERWARE MASTERPIECES FROM SOUTHEAST ASIA

262 Manuscript with Coverboards

Burma, cover with raised and gilded decoration, inset with colored stones, manuscript page with decorated and gilded ends, text with black lettering on silver ground, late 19th or early 20th century

W 13.5 cm, L 57.5 cm, H 3 cm
Reference: Isaacs, pl. 78; BAM, p. 199

263 Manuscript with Coverboards

Burma, cover with raised and gilded decoration, inset with colored stones, manuscript page with decorated and gilded ends, text with black lettering on silver ground. Late 19th or early 20th century

W 16.5 cm, L 64 cm, H 4 cm
Reference: Isaacs, pl. 78

264 Manuscript with Coverboards

Burma, decorative gold and red lacquer cover, black lettering on red lacquer, early 20th century

W 16.5 cm, L 64 cm, H 4 cm
Reference: Isaacs, pls. 78, 81

RELIGIOUS ITEMS

265 Manuscript with Paper Cover

Cambodia, decorated cover with gold leaf on black lacquer, Khmer inscription, early 20th century

W 11 cm, L 34 cm, H 4.5 cm

Detail of 265 (open pages)

LACQUERWARE MASTERPIECES FROM SOUTHEAST ASIA

266 Manuscript with Coverboards

Burma, manuscript showing open pages with cover, raised and gilded decoration inset with colored stones, inscription in raised lettering on paper, late 19th or early 20th century

W 11.5 cm, L 55.3 cm, H 3.5 cm

Detail of 266 (showing cover inscription)

248

RELIGIOUS ITEMS

267 Large Box, Possibly Manuscript Box

Thailand, vertical wood box with cover sitting on stepped base, pink and black lacquer, gold decoration, unusual, early 20th century

W 19.5 cm, D L 37.8 cm, H 53.5 cm

LACQUERWARE MASTERPIECES FROM SOUTHEAST ASIA

268 Offering Vessel

Burma, red and gold lacquer, pictorial decoration showing temple with attendants, mythical creatures and animals, early 20th century

W 40 cm, H 76.2 cm

RELIGIOUS ITEMS

Detail of 268 (side)

LACQUERWARE MASTERPIECES FROM SOUTHEAST ASIA

269 Two Red Lacquer Offering Vessels

Burma, red lacquer, black undercoat showing through on one, early or mid-20th century

Left: W 35.5 cm, H 73.5 cm;
Right: W 38.5 cm, H 79.5 cm
Reference: Isaacs, pl. 4

RELIGIOUS ITEMS

270 Offering Vessel

Burma, red and black lacquer, early 20th century

W 34 cm, H 77 cm
Reference: Isaacs, pl. 4

Left: W 41.5 cm, H 81 cm;
Right: W 73 cm, H 70 cm

RELIGIOUS ITEMS

272 Three Large Offering Vessels

Burma, two red lacquer with tracings of gilding, one fully gilded, early to mid-20th century

Left: W 40 cm, H 79 cm;
Middle: W 36.5 cm, H 78.2 cm;
Right: W 44.3 cm, H 80 cm

LACQUERWARE MASTERPIECES FROM SOUTHEAST ASIA

273 Offering Vessel

Burma, red lacquer, some faded gilding, early or mid-20th century

W 34 cm, H 68 cm

274 Offering Vessel

Burma, Shan States, with exceptionally detailed molded decoration, gold over black lacquer, mid or late 20th century

W 30 cm, H 63 cm
Reference: Isaacs, pl. 91

256

RILIGIOUS ITEMS

275 Offering Vessel

Burma, green and red lacquer with incised floral decoration, early or mid-20th century

W 32 cm, H 69 cm

LACQUERWARE MASTERPIECES FROM SOUTHEAST ASIA

276 Large, Squat Offering Vessel

Burma, red lacquer over black, mid-20th century

W 35.5 cm, H 47 cm
Reference: Isaacs, pl. 92

RELIGIOUS ITEMS

277 Offering Vessel

Burma, molded and gilded decoration with Hintha bird at the top

W 37 cm, H 89 cm
Reference: LJ, pl. 380

259

LACQUERWARE MASTERPIECES FROM SOUTHEAST ASIA

278 Offering Vessel

Burma, gilded relief decoration,
inlaid with colored glass

D 37 cm, H 68 cm

Detail of 278 (side)

RILIGIOUS ITEMS

279 Offering Vessel

Burma, Mandalay, gilded with molded decoration inlaid with colored glass, early 20th century

W 36.5 cm, H 71.5 cm
Reference: Isaacs, pl. 391

LACQUERWARE MASTERPIECES FROM SOUTHEAST ASIA

283 Pair of Small Offering Vessels

Cambodia, one black lacquer, the other with red and black lacquer, both with bamboo decoration, early or mid-20th century

Left: D 21 cm, H 30.5 cm;
Right: D 19.5 cm, H 30.5 cm

RELIGIOUS ITEMS

284 Small Offering Vessel

Cambodia, gold and red decoration on black lacquer, early or mid-20th century

D 26.8 cm, H 45.5 cm

LACQUERWARE MASTERPIECES FROM SOUTHEAST ASIA

285 Small Offering Vessel

Cambodia, red and black lacquer, bamboo detailing, early or mid-20th century

D 19.5 cm, H 30.5 cm

Detail of 285 (top)

RELIGIOUS ITEMS

286 Small Offering Vessel

Cambodia, red and gold decoration on black lacquer with inset bamboo decoration, early or mid-20th century

D 21 cm, H 33 cm

LACQUERWARE MASTERPIECES FROM SOUTHEAST ASIA

287 Small Offering Vessel

Cambodia, red and gold decoration on black lacquer, with inscription, early 20th century

D 24.5 cm, H 27 cm

288 Small Offering Vessel

Cambodia, red and gold decoration on black lacquer, early 20th century

D 24 cm, H 27 cm

RELIGIOUS ITEMS

289 Small Offering Vessel

Cambodia, alternating bands of red and black lacquer, early or mid-20th century

D 31.5 cm, H 38 cm

290 Small Offering Vessel

Cambodia, gold and red lacquer decoration on black lacquer

D 19.5 cm, H 27.5 cm

Sculptures

LACQUERWARE MASTERPIECES FROM SOUTHEAST ASIA

291 Seated Buddha

Burma, dry lacquer, crowned and adorned with royal costume, decorated with gold leaf and colored glass, with winged elements at the knees, cuffs, elbows, shoulders and crown, late 18th century or early 19th century

W 49 cm (at base),
D 31.5 cm, H 79 cm
Reference: MB, pl. 313

Previous pages:
Detail of 295 (face)

292 Seated Buddha

Burma, Mandalay, lacquer on bronze, elaborately gilded and decorated with colored stones, shell eyes, mid-19th century

W 24.5 cm, L 31 cm, H 46.5 cm
Reference: MB, pl. 119

LACQUERWARE MASTERPIECES FROM SOUTHEAST ASIA

293 Seated Buddha

Burma, Shan States, gold leaf over black lacquer, wood base, early 19th century

W 17.5 cm, L 31 cm, H 68.5 cm
Reference: MB, pl. 106

294 Buddha Head

Burma, dry lacquer and gold over red lacquer, late 18th century

W 15 cm, H 26.5 cm

LACQUERWARE MASTERPIECES FROM SOUTHEAST ASIA

298 Large Standing Buddha

Thailand, above a lotus base, gilded lacquer with color glass on metal, hands outstretched, late 17th or 18th century

W 29 cm, D 17 cm, H 81 cm

Detail of 298 (back of head)

LACQUERWARE MASTERPIECES FROM SOUTHEAST ASIA

299 Seated Buddha

Burma, red lacquer on wood with traces of gold leaf, late 18th century or early 19th century

W 33 cm, D 18.5 cm, H 55 cm

300 Seated Buddha

Thailand, stucco, gilded with traces of red and black lacquer

W 32 cm, D 11.5 cm, H 31.3 cm

SCULPTURES

301 Standing Monk

Burma, red lacquer on wood, some carved details, early 19th century

W 22.5 cm, L 76.5 cm, D 11.5 cm

302 Crowned Standing Buddha

Burma, Shan States, adorned with necklace and earrings, one hand outstretched, red lacquer on wood, fixed to a wood based, hands repaired, 18th century

W 28 cm, D 19 cm, H 120.5 cm

303 Spirit Figure with Hands Clasped in Prayer

Burma, Mandalay, weathered wood embellished with inlaid metal wire decoration, traces of original lacquer, early 19th century

W 28.5 cm, D 19.5 cm, H 105 cm

SCULPTURES

304 Pair of Dancers with Headdresses

Burma, gold and lacquer on wood, elaborate costumes, decorated with colored glass

Left: W 25.5 cm, D 13 cm, H 70 cm; Right: W 23.5 cm, D 13.5 cm, H 67.5 cm

305 Kneeling Monk

Burma, red lacquer on wood, gilded robe decorated with colored glass, 19th century

W 27 cm, L 25.5 cm, H 33 cm

306 Kneeling Monk

Burma, red lacquer with green glass decoration on head, gilded robe decorated with colored glass

W 23.5 cm, L 26.5 cm, H 35.5 cm
Reference: BAM, pl. 49

307 Seated Buddha

Burma, Shan States, black lacquer on wood, elaborate decoration with traces of gilding, carved base, late 18th century

W 30.5 cm, D 18.5 cm, H 67.5 cm
Reference: MB, pl. 89

308 Crowned Buddha

Burma, lacquer and gold on wood, partially eroded, 18th century

W 37.5 cm, D 24 cm, H 78 cm

309 Standing Buddha

Cambodia, red lacquer and gold, adorned with elaborate necklace and belt, figure largely eroded with sections of the body intact, 17th century

D 9.5 cm, W 21.5 cm, H 69 cm

310 Small Praying Monk

Thailand, gold leaf on metal,
18th century, possibly earlier

W 6.7 cm, H 18.8 cm

LACQUERWARE MASTERPIECES FROM SOUTHEAST ASIA

311 Seated Buddha

Cambodia, red and black lacquer on wood, hands folded in meditation pose, late 18th or early 19th century

W 17.5 cm, D 8.7 cm, H 34 cm

SCULPTURES

312 Seated Buddha

Burma, Shan States, red lacquer on wood, traces of gilding, 18th century

W 28.5 cm, D 13.5 cm, H 48 cm

Miscellaneous

313 Pair of Mythical Birds, Hintha

Burma, wood and metal body, elaborately decorated with colored glass, gold and lacquer, late 19th or early 20th century

W 23.5 cm, L 34.5 cm, H 33 cm
Reference: BL, pl. 6:36

MISCELLANEOUS

314 Mythical Animal Box

Burma, Nawarupa (chimeric creature),
black and red lacquer on wood,
late 19th or early 20th century

W 14.5 cm, L 30 cm, H 24.5 cm

LACQUERWARE MASTERPIECES FROM SOUTHEAST ASIA

315 Pair of Mythical Flying Horses or Imaginary Creatures

Burma, molded decoration, red lacquer on wood, early or mid-20th century

W 20.5 cm, L 65 cm, H 34 cm
Reference: MB, p. 471

MISCELLANEOUS

295

LACQUERWARE MASTERPIECES FROM SOUTHEAST ASIA

316 Owl Box

Burma, black lacquer and gold decoration on bamboo and wood, mid to late 20th century

W 7 cm, H 24.5 cm

MISCELLANEOUS

317 Group of Animal and Bird Boxes

Burma, lacquer on wood and coconut shell, mid-20th century

Left: W 8 cm, L 15 cm, H 9 cm;
Middle: W 9 cm, L 9 cm, H 8 cm;
Right: W 8.5 cm, L 13.3 cm, H 10 cm
Reference: LJ, pl. 350

318 Hanuman Box

Cambodia, red, green, blue and orange lacquer on wood, early or mid-20th century

W 10.5 cm, L 14 cm, H 6 cm

297

LACQUERWARE MASTERPIECES FROM SOUTHEAST ASIA

319 Carpenter's Plumb Line

Burma, lacquer on wood, decorated with pair of carved birds, mid-20th century

W 11 cm, H 47 cm

MISCELLANEOUS

320 Three Gilded Pumpkin Boxes

Burma, gold on black lacquer, late 20th century

Left: W 13.8 cm, H 10 cm;
Center: W 11.3 cm, H 9 cm;
Right: W 11.6 cm, H 10.5 cm
Reference: BL pl. 5:55

321 Two Pumpkin Boxes

Burma, black pumpkin box, with smaller green lacquer box decorated with gold dots, early or mid-20th century

Larger: W 19.3 cm, H 13.3 cm;
Smaller: W 14.2 cm H 10 cm

299

322 Carved Spoon Case

Thailand, carved, lacquered and hinged, wooden case with enclosed mother-of-pearl spoon

W 7 cm, L 20 cm

Detail of 322 (interior showing mother-of-pearl spoon)

MISCELLANEOUS

323 Large Pumpkin Box

Burma, black lacquer with red lacquer, open to show interior tray with three compartments, mid-20th century

W 19.3 cm, H 13.3 cm

324 Two Durian Boxes

Burma, both gold on wood with red lacquer interiors, the smaller durian box with fitted bottom plate

Large: W 20.5 cm, H 20 cm;
Small: W 7 cm, L 7.5 cm + small tray
W 10 cm, H 1.5 cm
Reference: LJ, pls. 214, 215

301

LACQUERWARE MASTERPIECES FROM SOUTHEAST ASIA

325 Spotted Bamboo Container

Cambodia, cylindrical bamboo container for joss sticks or candles, with woven bamboo bands, early to mid-20th century

W 6 cm, H 27.5 cm

326 Woven Bamboo Container

Cambodia, tightly woven cylindrical bamboo container for joss sticks or candles, early to mid-20th century

W 7 cm, H 20.7 cm
Reference: Vithi, p. 61

327 Carved Bamboo Container

Cambodia, cylindrical container for joss sticks or candles, incised design with red and black lacquer, early to mid-20th century

W 6 cm, H 20.7 cm

328 Group of Five Cylindrical Containers

Cambodia (three on the left), Thailand, (two on the right), two with woven bamboo, one with incised decoration, two black lacquer containers, likely for joss sticks or candles, early or mid-20th century

Reference: Vithi, p. 61

LACQUERWARE MASTERPIECES FROM SOUTHEAST ASIA

336 Headrest

Burma, gold on black lacquer, small drawer on side, early 20th century

W 10 cm, L 22 cm, H 11 cm

337 Pillow Box

Burma, black lacquer with decorative metal inlay, mid-20th century

W 8.9 cm, L 22.2 cm, H 11.6 cm

MISCELLANEOUS

338 Small Round Container

Thailand, black lacquer on wood, decorative mother-of-pearl inlay, late 19th or early 20th century

W 10 cm, L 12 cm, H 7 cm

339 Betel Leaf Holder

Burma or Thailand, black lacquer with bamboo decoration

W 3 cm, L 8 cm, H 11 cm

340 Small Domed Box

Burma, Shan States, unusual shape, early 20th century

D 14.6 cm, H 12.6 cm

309

LACQUERWARE MASTERPIECES FROM SOUTHEAST ASIA

341 Spittoon

Thailand, red and black lacquer, floral decoration, mid-20th century

W 17.5 cm, H 12 cm

342 Spittoon

Thailand, black lacquer with red lacquer decoration and interior, butterfly faintly visible

W 19.5 cm, H 14.5 cm

Detail of No. 341 (depicting a butterfly design)

MISCELLANEOUS

343 Sword with Scabbard

Burma, gold and black lacquer on metal, raised decoration, early 20th century

L 70 cm, H 4 cm, W 3 cm
Reference: Karow, pl. 119

LACQUERWARE MASTERPIECES FROM SOUTHEAST ASIA

344 Pair of Loom Spindles

Cambodia, red lacquer with
some gilding on wood,
early 20th century

W 14.5 cm, D 4.5 cm, H 46 cm
Reference: Vithi, p. 61

MISCELLANEOUS

345 Tambourine

Cambodia, goatskin on wood, black lacquer with inlaid mother-of-pearl decoration, late 19th or early 20th century

W 23 cm, H 6.8 cm

346 Two Horse Hair Brushes

Cambodia, black and red lacquer carved handles, traces of gilding, early 20th century

Left: W 12.1 cm, H 22.8 cm;
Right: W 20.3 cm, H 17.2 cm

LACQUERWARE MASTERPIECES FROM SOUTHEAST ASIA

347 Unusual Oval Box

Burma, with double round top, probably food container, black lacquer with bamboo detailing, rare form, early to mid-20th century

W 15.5 cm, L 25 cm, H 17 cm

348 Covered Bowl

Burma, serving dish, with side handles, top decorated with pair of birds, early to mid-20th century

W 28 cm, H 14.3 cm
Reference: BL, pl. 5:44

MISCELLANEOUS

349 Tall Square Box, Possibly Open Betel Tray

Cambodia, affixed to larger square base, both decorated with gold on red lacquer, mirror glass inserts, early to mid-20th century

D 25.3 cm, H 33.7 cm

About the Collector

David Halperin is an American lawyer who has lived in Hong Kong since 1976. He grew up in Southern California and graduated in 1965 from Columbia University with a degree in American History. He served as a naval officer from 1966-1970, including an 18-month tour of duty in Vietnam, where he was an aide to Admiral E.R. Zumwalt, Commander of Naval Forces in Vietnam and later Chief of Naval Operations. After leaving the Navy he spent a year on the National Security Council as Personal Assistant to Dr. Henry Kissinger. He then attended Harvard Law School from which he graduated in 1974, after which he initially joined Davis Polk & Wardell in New York before moving in 1976 to the newly established Hong Kong office of Coudert Brothers. He has lived in Hong Kong since that time, practicing as a banking and corporate lawyer, most recently with Orrick, Herrington & Sutcliffe, before his retirement in 2020.

He has recently spent more time focusing on Altfield Gallery, an antique gallery and design business which he established in 1982 with his business partner, Amanda Clark, an English interior designer. Initially specializing in Chinese furniture, the focus of the business gradually expanded to include sculpture and the decorative arts from Southeast Asia. Traveling throughout the region regularly for more than 50 years, he was able to assemble a large collection of lacquer objects, many of which are illustrated and catalogued in this volume.